vintage pattern

1950s

Marnie Fogg

BATSFORD

Acknowledgements

As ever, many thanks to the amazing photographer Allan Hutchings. Thanks to Tina Persuad, Lucy Smith, Gemma Wilson and all at Anova Books, John Angus, Professor Caroline Cox, Emily Angus, Jo Hoon, John and Rose Pegg, Khalid Siddiqui, Pam Hemmings, Patrick Young of Vintage Modes at Grays Antique Market, Sparkle Moore & Cad Van Swankster at The Girl Can't Help It, Mid-Century American Vintage, Alfies Antique Market (www.thegirlcanthelpit.com), Simon Alderson at www.twentytwentyone.com, Vicky Begg and the Centre for Advanced Textiles, The Glasgow School of Art, Glasgow (www.classictextiles.com).

Picture Credits

Allan Hutchings Photography: 3, 17, 18, 19, 20, 22, 24, 25, 26, 30-31, 34, 35, 37, 39, 41, 41, 42, 43, 44, 45, 47, 48, 49, 50, 51, 52, 54, 55, 56, 57, 58, 59, 60, 61, 64-65, 68, 69, 70, 71 76, 77, 78, 79, 80, 81 82, 83, 84, 85, 87, 88, 89, 90,91 92, 93, 94, 95, 96, 97, 99, 100, 101 left, 101 right, 111, 115, 116, 118, 119, 121, 122, 123, 124, 126, 127, 128, 129, 130, 131, 132, 134-135, 136, 140-141, 144, 145, 146, 147 148, 149, 150-151, 153, 157, 158, 159, 160, 162, 166, 167, 177

John Angus: 7, 8 left, 8 right, 10, 13, 15, 27, 33, 47, 62-63,92, 102 top, 102 bottom, 103 top, 103 bottom, 104, 105, 106, 107 108, 109, 120, 164-165, 167, 168, 178, 179 180, 181, 182, 183. Centre for Advanced Textiles, The Glasgow school of Art (www.classictextiles.com): 20, 28, 29, 32, 36, 38, 40, 72,73 74, 75, 98, 112, 113, 114, 117, 118, 136, 137, 142, 143, 154-155, 156, 160, 163.

Fabrics courtesy of Khalid Siddiqi: 56, 57

Partick Young of Vintage Modes, at Grays Antique Market (www.graysantiques.com): 64-65, 83

Simon Alderson, TwentyTwentyOne (www.twentytwentyone.com), 274 Upper Street, London, N1 2UA: 3, 17, 18, 19, 20, 22,23, 26, 30-31, 36, 39, 41, 42, 43, 44, 45, 87, 88, 89, 90, 91, 93, 94, 96, 97 111, 114, 115, 118, 119, 121, 123, 124, 126, 127, 128, 129, 130, 131 132, 134-135, 136, 144, 145, 146, 147,148, 149, 150-151, 153, 157, 158, 159, 167.

Sparkle Moore (www.thegirlcanthelpit.com), Alfies Antique Market, 13-25 Church Street, London NW8 8DT: 50, 51, 52-53, 54, 55, 58, 59, 60, 61, 67 68, 69, 70, 84

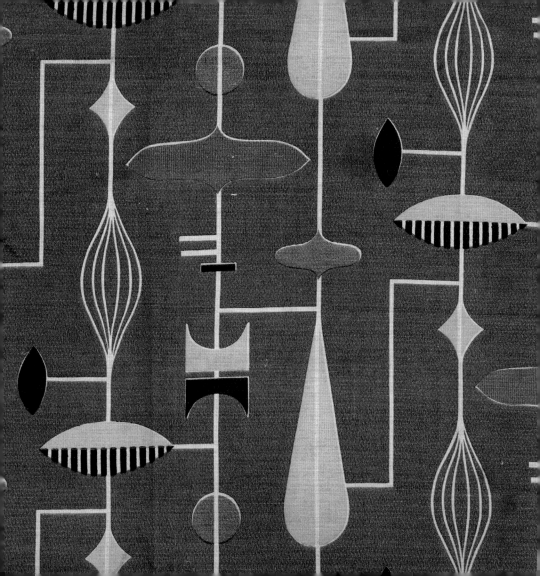

To my friend Jenny Hoon

First published in the United Kingdom in 2013 by
Batsford
10 Southcombe Street
London
W14 0RA

An imprint of Anova Books Company Ltd

Images and text taken from *1950s Fashion Prints*, Marnie Fogg (2010)

ISBN: 978-1-84994-094-8

A CIP catalogue record for this book is available from the British Library.

10 9 8 7 6 5 4 3 2 1

Reproduction by Mission Productions Ltd, Hong Kong
Printed by Toppan Leefung Printing Ltd, China

This book can be ordered direct from the publisher at the website:
www.anovabooks.com, or try your local bookshop.

Contents

Introduction

Postwar print design was no place for the lavish, the nostalgic or the grandiose. The drab utilitarian years of the Second World War gave way to an analytical approach to design that had a lightness and freshness complicit with an optimistic desire for a new world founded on modernity, originality and innovation. Art, architecture, interiors and textiles all came together under the banner of 'contemporary,' meaning to live in the present time, a look that encompassed acid colours, abstract form and idiosyncratic detail.

The 1950s saw an end to the restrictions on colour in printed textiles (five colours and only small repeats allowed by the 'Utility' rationing programme of 1942) and the shortage of a workforce that were the result of war-time austerity. A contributing factor to the innovations and design development of the textile industry was the shift in emphasis away from the production of war-time necessities to domestic concerns, all the more important as people had to be rehoused after the wholesale destruction of many of Britain's cities. Homebuilding meant a renewal of interest in domestic textiles and wallpaper design.

Transformative and experimental, print designers relished the opportunity to break with the past and accrue motifs, images, colours and textures from an eclectic variety of sources. Design of the period was characterized by a preoccupation with form and structure and a fascination with motion. Influences ranged from the distorted, attenuated form of the Skylon – an engineering marvel erected in 1951 to mark the Festival of Britain – to the elongated figures of Italian sculptor Alberto Giacometti and the underlying structure of natural form. Interest lay in the plant skeleton rather than the bloom, seed heads rather than the

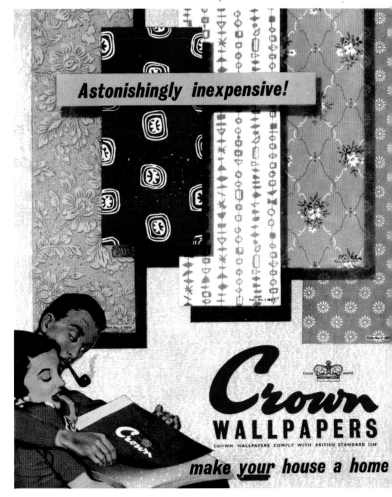

Right: Crown Wallpapers advertisement with an emphasis on affordable modernity. The company played safe with the inclusion of two 'conservative' samples alongside three that have a more contemporary feel.

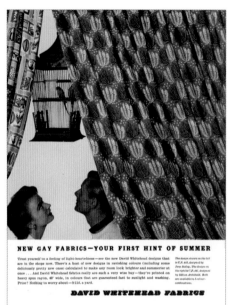

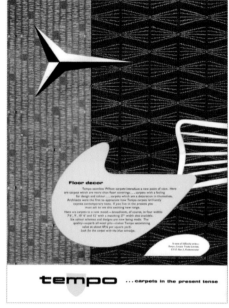

Above: David Whitehead produced contemporary fabrics for the mass market. This advertisement for printed fabric for curtains appeared in the popular home and interiors magazine *Homes & Gardens*. It was company policy to attribute the designs to the designer; in this case June Bailey (left) and Gillian Archibald (right).

Above: Advertisement in *Homes and Gardens*, April 1957. The boomerang shape was ubiquitous to this period, deployed in product, graphic and textile design. It was used to indicate forward thinking, movement and progress and may have had its origins in the shape of the artist's palette, also a popular motif of the time.

blossom, and leafless trees rather than foliage. A sense of lightness and levity was also introduced by motifs that danced and spun across print designs inspired by the mobile, an art form popularized by the American sculptor Alexander Calder. Motifs that typified the era could also be sourced in the brightly coloured scattered abstract shapes and fragile, wandering lines found in the work of artists Paul Klee and Joan Miró. Satellites and space travel provided the starburst and the Sputnik, and the parabolic curve of the ubiquitous boomerang shape could be found on products from furniture to curtains.

The 'Britain Can Make it' Exhibition launched in 1946 by the newly formed Council of Industrial Design (CoID) encouraged the emergence of this new design aesthetic, alongside a campaign to educate the British public in the constituents of good design. This included the establishment of high quality art and design courses such as those run by London's Central School of Arts and Crafts in London, led by influential figure Dora Batty, and London's Royal College of Art.

In 1951, London's skyline was transformed by the Skylon. Part sculpture, part building, the Skylon was designed by architects Powell and Moya. Seemingly precariously balanced on three 'legs' it appeared to float above the South Bank. Seven hundred and sixty-two metres (250 ft) tall, the Skylon became a symbol of the Festival of Britain, a government-sponsored celebration of the best of British design, art and industry. It was a showcase of modern style for the atomic age. Twenty-six manufacturers of wallpaper and printed and woven dress and furnishing fabrics were invited by the Council of Industrial Design to produce designs for the Festival of Britain, and although these were predominantly textiles, associated products such as vinyl, plastic laminates and ceramic tiles were also produced for the exhibition. The emphasis on textiles was in recognition of the importance of the industry to the British economy, and was also due to the fact that the chairman of the Council of Industrial Design was Sir Thomas Barlow, owner of Barlow and Jones, a leading cotton manufacturer.

Exhibiting at the Festival enabled British designer Lucienne Day to launch her successful career as one of Britain's most important textile designers of the 20th

Left: A magazine illustration from *Homes & Gardens* magazine, conveying the plethora of choice available for both fashion fabrics and home furnishings.

century. Her landmark design *Calyx* was used within the Homes & Gardens Pavilion and proved enormously influential. The fabric was retailed through Heal Fabrics, an offshoot of furniture store Heal & Son. Textile converters rather than manufacturers, the company bought in print designs from freelance designers and commissioned printers such as Bernard Wardle to produce them, as was the case with Day's *Calyx*. Tom Worthington, managing director of the company from 1948 to 1971 also commissioned designers Barbara Brown, Michael O'Connell, Dorothy Carr, Roger Nicholson and Fay Hillier, amongst many others, resulting in Heal Fabrics becoming one of the pioneers of British contemporary design in home furnishings.

Innovation in print design was initially restricted in the main to furnishings, wallpapers and surface decoration on products such as plastic laminates; fashion came a very poor second. The 1950s silhouette was concerned with ladylike tailoring and the hourglass figure, it was not until the emergence of the 'teenager' at the end of the decade that fashion print began to display the novelty and whimsy of print designed for interiors. Subjects for fashion print design tended to lean towards a more traditional interpretation of floral motifs that were then made up into the shirtwaist dresses and gathered skirts that reflected Dior's Corolle line (dubbed the New Look by journalists). Parisian couturier Christian Dior produced a ready-to-wear suit in 1953 printed with a *tachist* design (from the French to stain, spot or blot), but in general contemporary style in fashion fabrics did not permeate the mass market in the way that it did in interior design. Specializing in high quality cotton dresses, very often featuring prints of horizontally banded stripes alternating with florals, British manufacturer Horrockses was formed in 1946. Ascher (London) Ltd also produced designs for silk and rayon dress fabrics that were popular with the European couturiers.

Arthur Stewart-Liberty of London store Liberty invited Royal College of Art graduate Colleen Farr to establish a design studio to work on dress fabrics for the company. There is a marked contrast between her muted stylised florals such as *Sheena* and *Lucilla* and the contemporary aesthetic of furnishings designer Robert

Stewart. His designs, such as *Macrahanish,* for the same company featured the juxtaposition of witty figurative motifs and an intense colour palette. Head of printed textiles at Glasgow School of Art from 1949 to 1978, Stewart was the designer most closely associated with the fabrics produced under the banner 'Young Liberty'. Launched in 1949, the label included collaborations with Jacqueline Groag, Pat Albeck, Hilda Durkin and Martin Bradley. Scottish designer Sylvia Chalmers was a contemporary of Robert Stewart at the Glasgow School of Art. On graduating from the college in 1951, she designed murals and textiles for fashion designer Elizabeth Eaton before becoming one of the young, talented core group of designers at Heal's. Preferring the freedom to experiment, Chalmers established her own company, Tuar Fabrics (a Gaelic term meaning brightness or appearance). Her long-forgotten archive was discovered on her death in 2007, and presented to her alma mater, the Glasgow School of Art, where her designs have been digitally remastered by the GSA Centre for Advanced Textiles.

The British design establishment benefited from the influence of European trained designers fleeing from war-torn Europe. These included Marian Mahler and Jacqueline Groag, both of whom studied at the Vienna Kunstgewerbeschule. Groag produced designs for the Wiener Werkstatte in the 1920s before emigrating to France to avoid the Nazi invasion. Once there, she designed fabrics for Schiaparelli and Lanvin, before moving to London at the outbreak of war. She built up her practice and worked for David Whitehead, Liberty's, and Heal and Sons, as well as producing designs for the Design Division of the Associated American Artists.

Graduates from the new textile design courses needed to persuade long-established textile companies of their commercial credibility, and one of the first to respond was Manchester-based company David Whitehead Ltd, who spearheaded the way to producing contemporary design for the mass market. According to designer Lucienne Day this was 'the firm who broke with tradition and gave the mass market gay, colourful and imaginative designs. Whitehead became synonymous with the contemporary print,

Right: Horrockses Fashions was founded in 1946 as a subsidiary of Horrockses, Crewdson & Company and specialized in high-quality printed cottons, which were designed in-house. The familiar horizontally banded patterns that came to be associated with the company were the work of Alastair Morton, who was also the design director of Edinburgh Weavers.

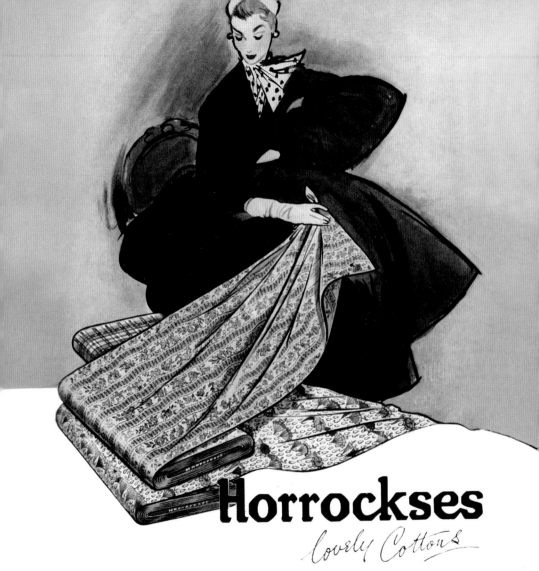

Horrockses

lovely Cottons

banishing forever the era of the muddy floral and 'folksy' print patterns.'[1]

The novel idea of attributing fabrics to named designers was the brainchild of John Murray, an architect with no previous experience in textile design who was appointed as the Director of Furnishing Fabrics at David Whitehead Ltd. He instigated a series of high profile advertising campaigns including one featuring in-house designer Anne Ashworth, responsible for the hugely successful *Ravenna* range of designs.

Other commissions with young designers and artists followed, including collaborations with John Piper, Roger Nicholson, Terence Conran, Marian Mahler and Jacqueline Groag. The Festival of Britain provided the company with a great marketing opportunity when twenty designs were chosen for display, including those by Jacqueline Groag and Terence Conran. John Murray left David Whitehead in 1952 to be replaced in a new role as design consultant in 1953 by another architect, Tom Mellor. Under his aegis the company consolidated their reputation as the leading manufacturer of contemporary textiles in Britain.

Increased production was aided by the introduction in 1957 of an automatic screen printing process. In 1958 *Design* magazine published an article entitled 'Leadership reasserted: new scope and variety for mechanical screen prints'. It reported that 'after much experiment with relatively high-priced hand screen prints, many of them by well known artists, Whitehead's now offer to the mass market the first large range of machine screen prints [...] Machine screen printing is not new in itself, but this application of the technique to furnishings in a major range is a most important British development'.[2]

Hull Traders also had their place in democratizing contemporary design. Established in 1958, Time Present was a range of home furnishings hand screen printed with pigment dyes (those that float on the surface of the cloth, as opposed to vat dyes which penetrate the cloth. This enables colours to be mixed to produce extra colours). Their aim was to produce short runs of avant-garde textiles, while still being affordable. Designers who collaborated with the company included Eduardo Paolozzi, Althea McNish and Humphrey Spender.

By the end of the 1950s an entirely new aesthetic was in place, utilizing a design vocabulary that represented all that was new and modern. Vitality in colour and idiosyncratic imagery were mediated through the preoccupations of contemporary life; scientific progress, modern art, the new consumerism. This was helped by technical advances and innovations but, above all, by the ebullient creativity of the textile designers themselves.

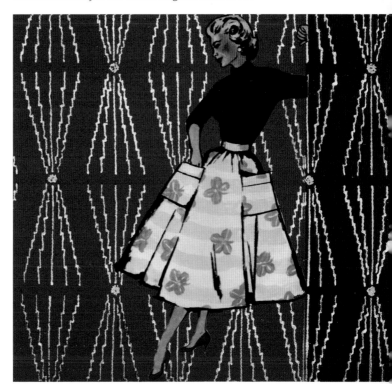

Right: The 1950s fashionable silhouette; the small waist, circular skirt and stiletto-heeled shoes against a backdrop of gathered stripes.

Abstraction

Intrinsic to 1950s print design was the deployment of abstraction by textile designers, who referenced the artistic movement of the day. Rather than attempting to represent recognizable reality, abstract art creatively organized shapes, forms and colours which had no counterparts in nature. Concurrent with this was the abstraction of pattern from natural phenomena such as the skeletal plant forms celebrated by designers such as Lucienne Day.

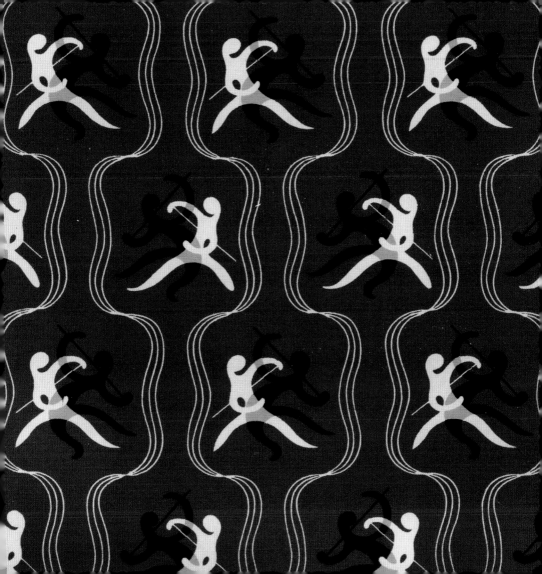

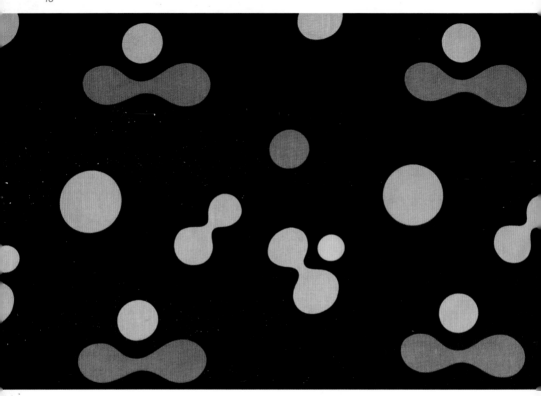

Previous page: In this design by Gerald Downes for David Whitehead in 1955, a dancing couple are rendered so simply by the designer that they form an abstract motif.

Above: Molecular organic shapes floating on a flat, coloured ground by pioneering abstract artist Paule Vezelay in this design Contrasts for Heal Fabrics.

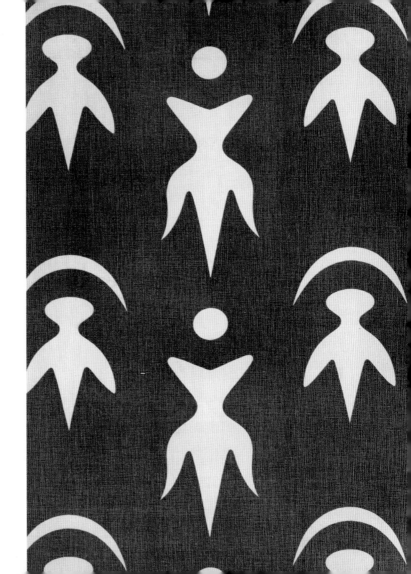

Right: Paule Vezelay describes an ebullient dancing abstract form in *Variations* from 1956 for Heal Fabrics.

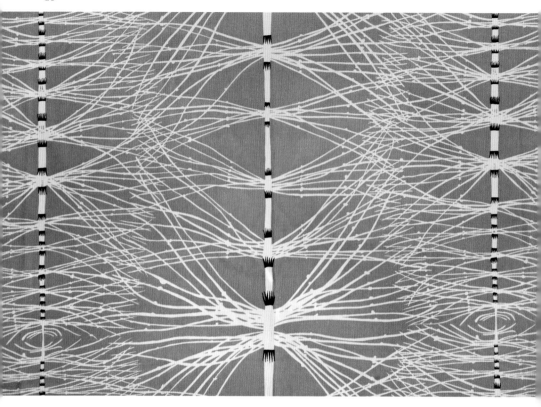

Above: *Mare's Tails* by Edward Pond, head designer
from 1958 at Bernard Wardle's Everflex branch in
Wales. Wardle fabrics were produced with colourfast
vat dyes, which replaced chrome dyes in the mid-fifties.

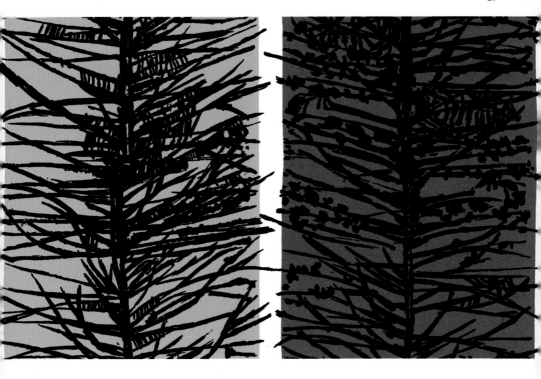

Above: Architectural in scale, the natural geometry of trees is conveyed by the use of bold, vertical dramatic lines in this design, *Larch*, by Lucienne Day. The pattern is divided into two halves of contrasting colours, unified by the strong graphic lines of the trees.

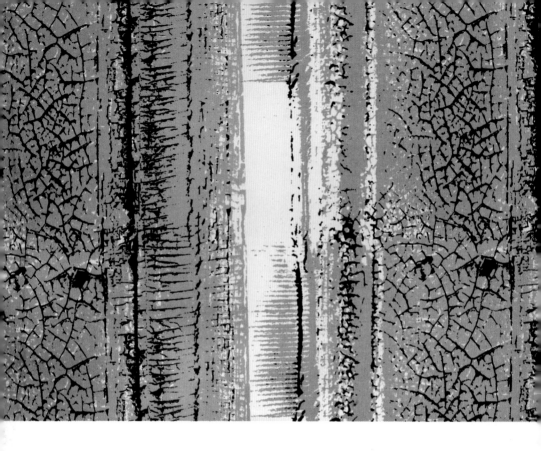

Above: *Too Many Coats* by Scruggs-Myers/Moir Uglow describes a textured surface of cracked, broken lines that replicate the layers of crazed overpainting, or craquelure.

Right: Skeletal leaf and plant forms inspired Lucienne Day, as in this design, *Linden*, where the linear motif is superimposed on planes of subdued harmonious colour.

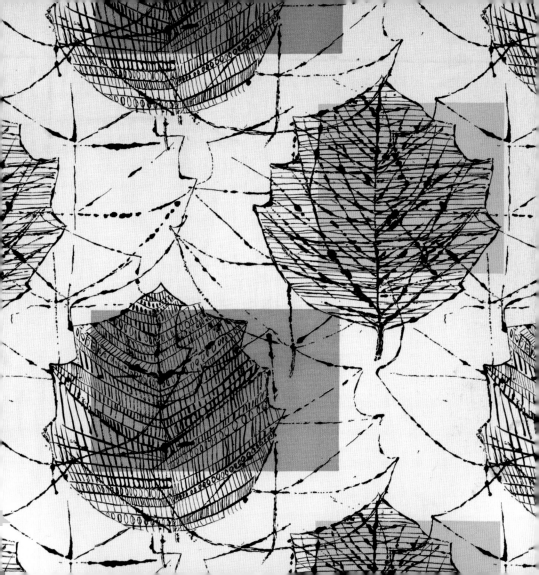

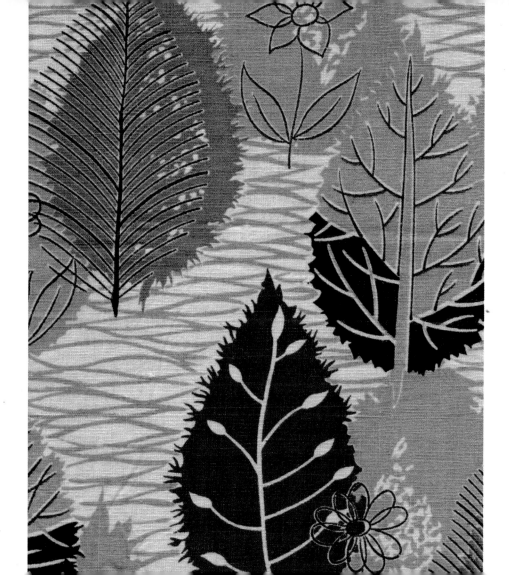

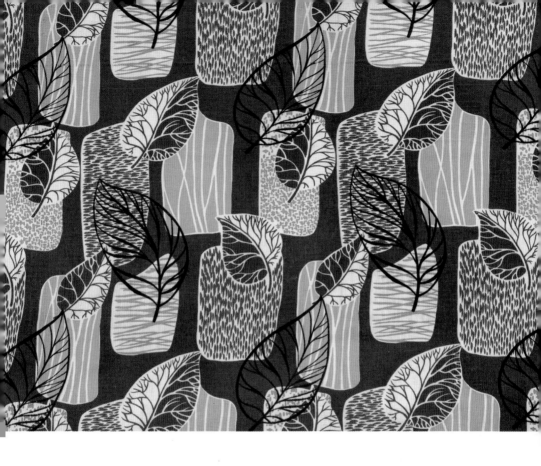

Left: Designers for the mass market ranges of textiles were eager to use the stylized motifs of influential designers such as Lucienne Day, often producing similar work but without the finesse.

Above: A design typical of the era, both in colourway and in subject matter – skeletal leaves floating on a background of textured bark-like modular shapes and the traditional half-drop repeat format.

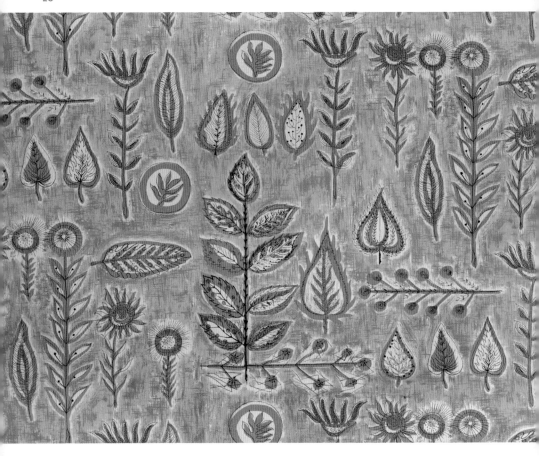

Above: An unbranded domestic furnishing fabric of freely executed skeletal leaf motifs that evidence a 'folkloric' quality in their simplicity.

Right: Simple graphic descriptions of abstract trees positioned in geometric shapes isolated from a roughly drawn background of broad, overlapping brush strokes.

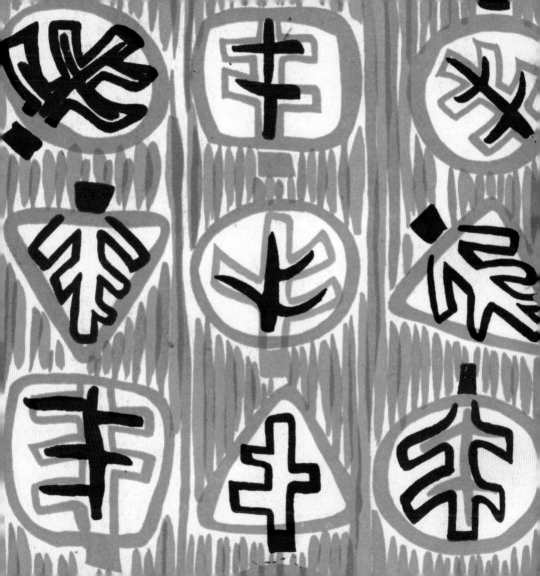

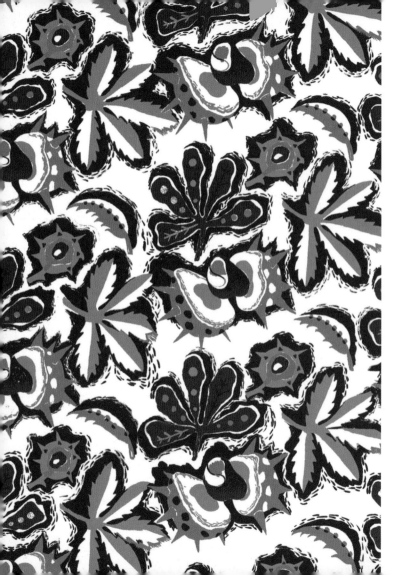

Left: The leaves, shell and nut of the chestnut tree are abstracted and positioned on a white background which energizes the composition, as do the marks surrounding each image in this design, *Chestnuts* by Scottish designer Sylvia Chalmers.

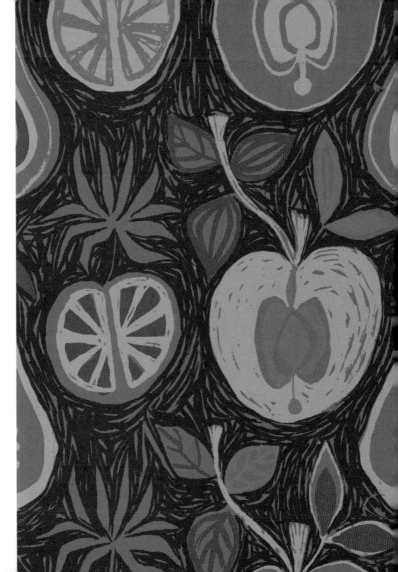

Right: *Fruit* by Sylvia Chalmers. The ubiquitous 1950s motif of cut fruit is given a graphic substance on a lively dark textured background and with a relatively small scale repeat size measuring 15.10cm (6in) wide and 20.14cm (8in) high.

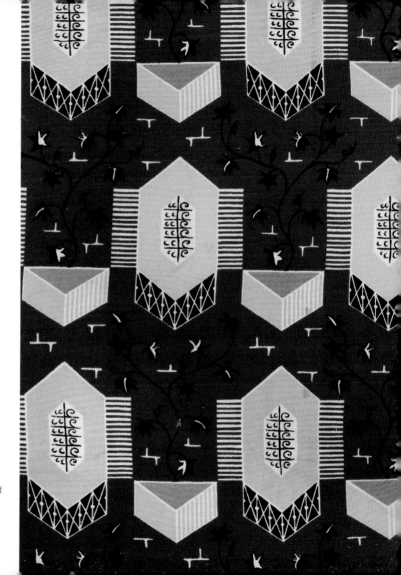

Right: A David Whitehead Fabric, which was produced in a variety of colourways.

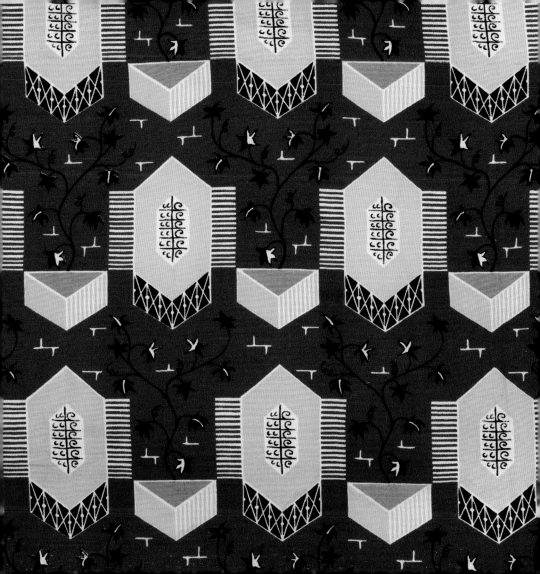

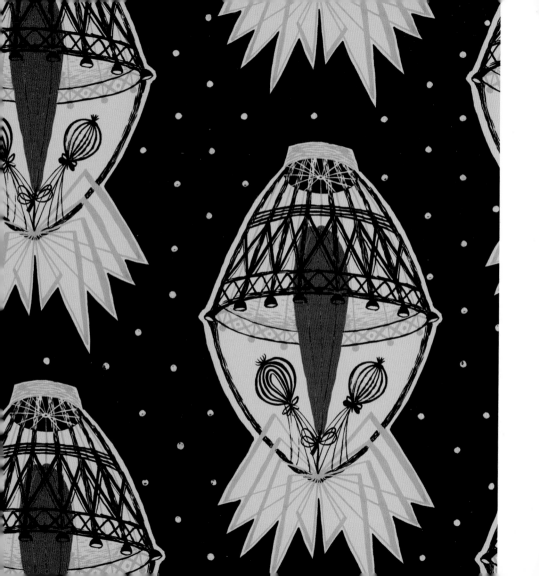

Left: *Balloon* by Scottish designer Sylvia Chalmers features hot-air balloons against a polka-dot sky in half-drop repeat measuring 60.19cm (24in) in width and 101.85cm (40in) in height.

Right: Large in scale, *Sea Holly*, a vertical print by Helen A. Dalby for David Whitehead was designed to go from floor to ceiling. Dalby also worked for Edinburgh Weavers.

sea holly *one of the famous range of*
DAVID WHITEHEAD FABRICS *guaranteed*

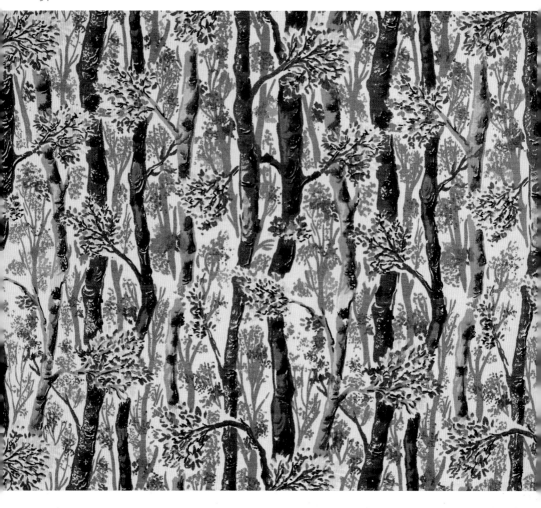

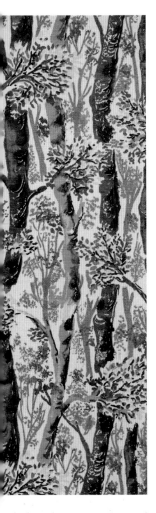

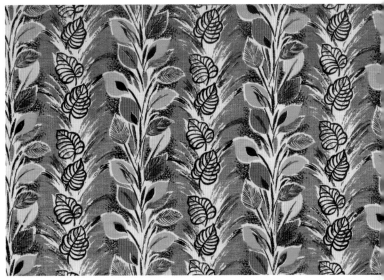

Above: Another basic stripe layout is enlivened by skeletal leaf shapes and loosely rendered foliage in this unbranded furnishing fabric.

Left: The rough texture of the bark cloth complements the print design of layered tree trunks and impressionistic foliage which forms a cleverly disguised stripe repeat.

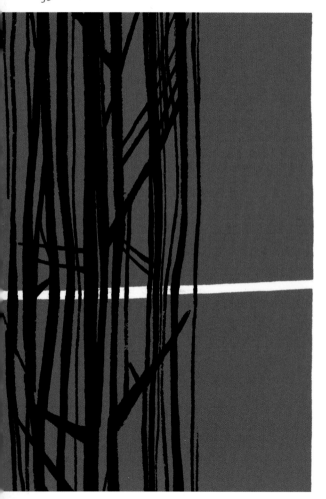
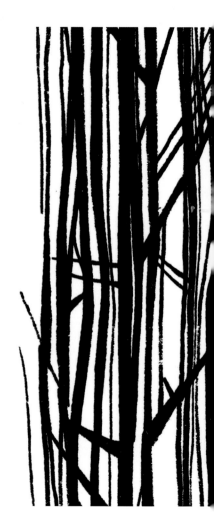

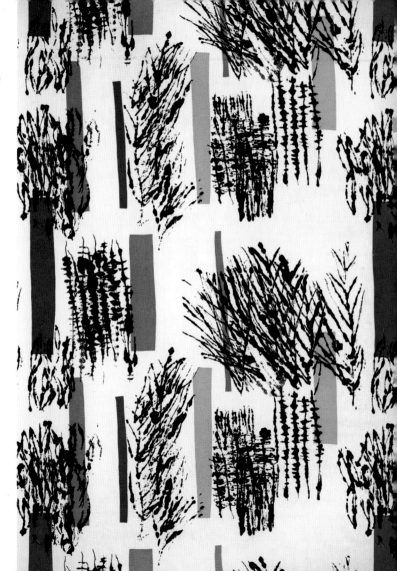

Left. Screen printed onto cotton crepe, *Sequoia*, designed by Lucienne Day in 1959, is an example of the designer's utilization of different coloured panels held together by strong graphic effects.

Right: As the decade progressed Lucienne Day worked with an arboreal theme. *Maquis*, produced by Heal's in 1959 juxtaposes irregular blocks of colour with roughly textured areas.

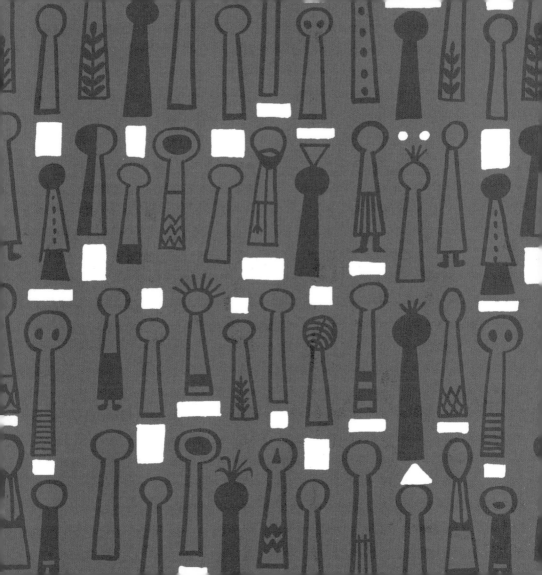

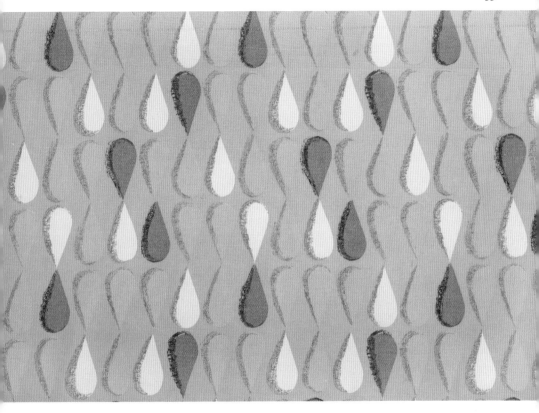

Left: An intriguing juxtaposition of keyhole-shaped people observed through keyholes in this wittily entitled design, *Peeps* by Sylvia Chalmers, measuring 30.62cm (12in) in width and 21.12cm (8¹⁄₄in) in height.

Above: Carefully poised teardrop shapes in a subtly controlled colour palette are given depth and movement by a Taschist flick of oil pastel in dark tones.

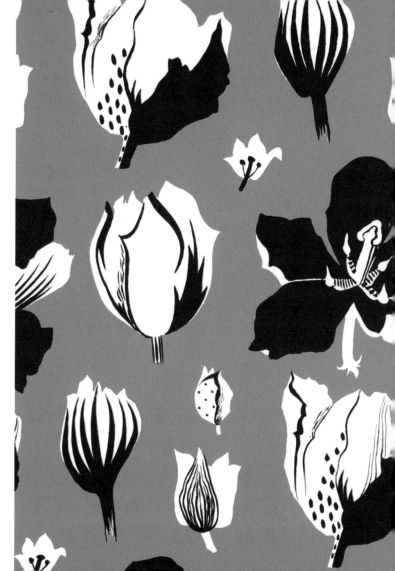

Right: Dramatic monochrome flower heads on a flat background in this design by Sylvia Chalmers. *Tulips* has a repeat size measuring 22.96cm (9in) wide and 42.40cm (16¾in) in height.

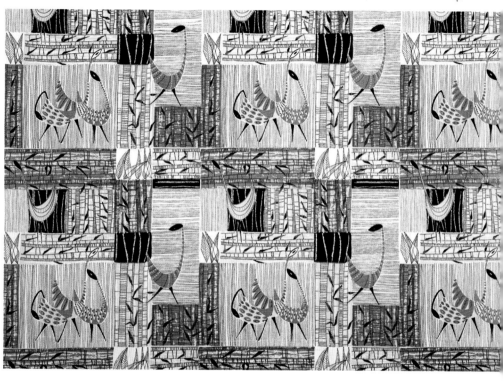

Above: The grid layout of this design for a furnishing fabric is formed by sections of stylized bamboo. The legs of the highly decorated birds suggest the spindly insubstantial legs of contemporary furniture.

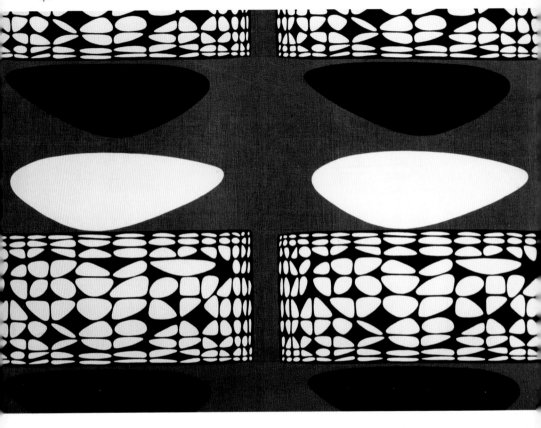

Above: The irregular disposition of loose rectangles suggests a deliberate absence of equilibrium in this geometric composition.

Right: Collage was a popular design device during the 1950s, allowing for the ubiquitous use of rough line drawings over flat planes of colour.

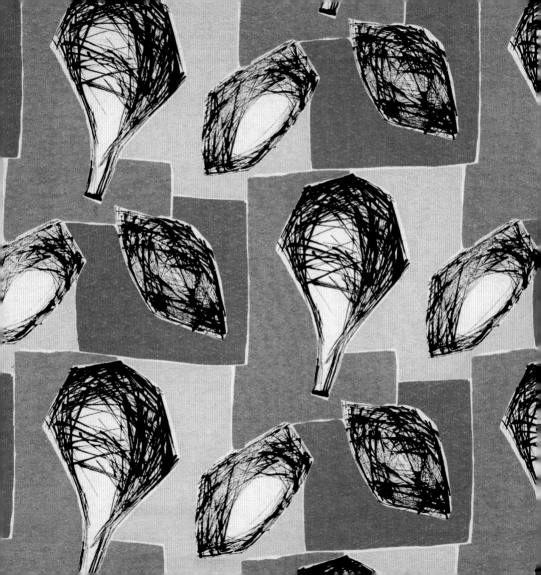

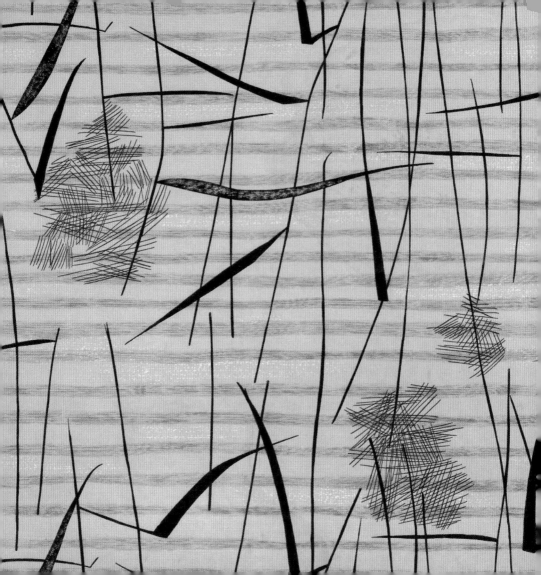

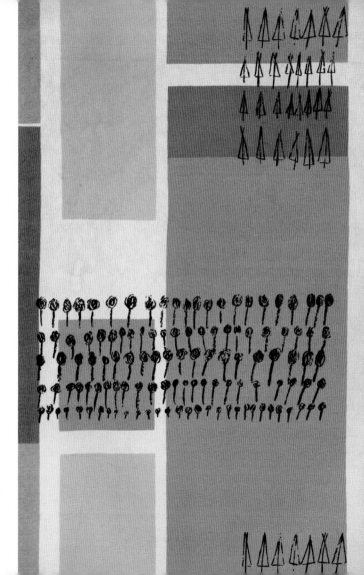

Left: A confident calligraphic single brush stroke forms the wild grasses of *Tarn*, designed by Lucienne Day in 1958. The fabric was produced by Heal's; this design is one of nine colourways.

Right: Blocks of colour are superimposed with linear motifs of stylized deciduous and coniferous forests in this design *Plantation* by Lucienne Day, designed in 1958.

Narrative, Novelty & the Jive

During the 1950s idiosyncratic subject matter and whimsical imagery presaged the use of popular culture as art form later seen in the work of the Pop Artists of the 1960s. Alongside the preoccupation with abstraction and the attenuated shapes embellishing mainstream textile design, conversational prints – those that depicted a real creature or object – were also popular. These appealed to the newly emerging teenager, eager to differentiate her clothes from those of her mother. Swirling circular skirts, held up by layers of stiffened nylon petticoats, featured motifs taken from rock 'n' roll, love hearts and messages. A version of the princess line, dresses darted to fit and flare into a gored skirt, utilized bright floral designs and was popularized by Sandra Dee and Connie Stevens.

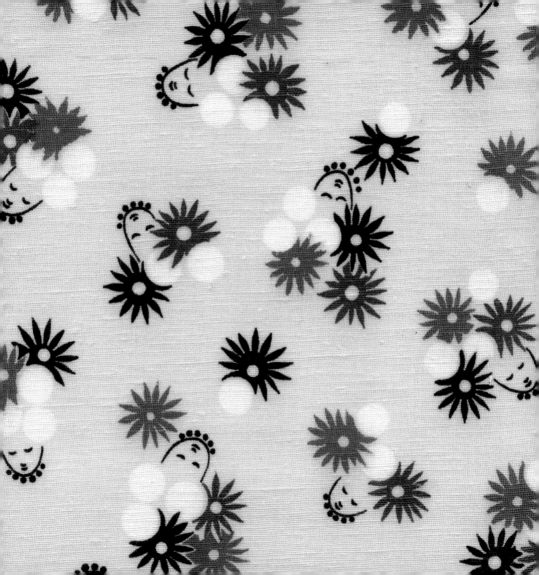

Previous page: The influence of the cinema can be seen in this four-colour print, featuring screen idol and popular entertainer Carmen Miranda.

Right: Printed cotton handkerchiefs were particularly popular in the United States during the 1940s and 50s. Josephine Baker inspired this facsimile airmail letter from Paris featuring the dancer as New York's Statue of Liberty.

Opposite: Expressive brush strokes interpret the flowing lines of ballerinas poised in a multi-directional repeat, unusual in a figurative design.

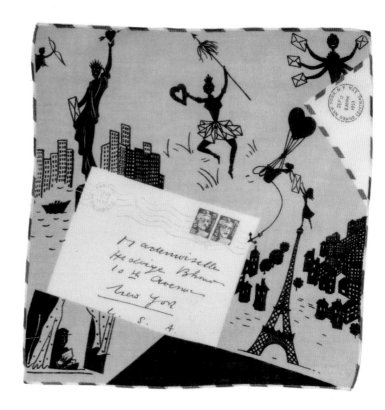

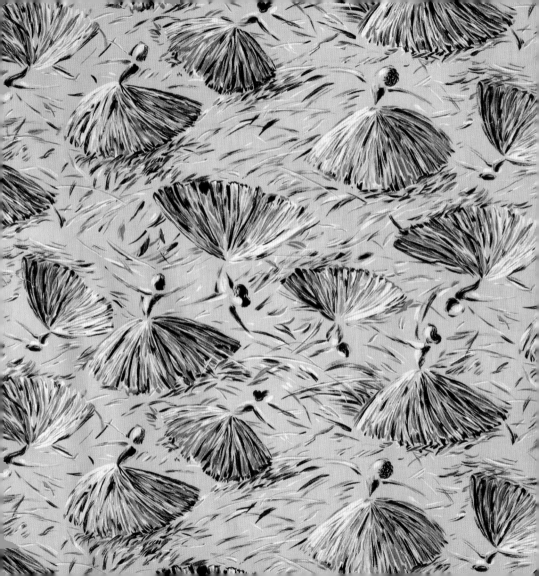

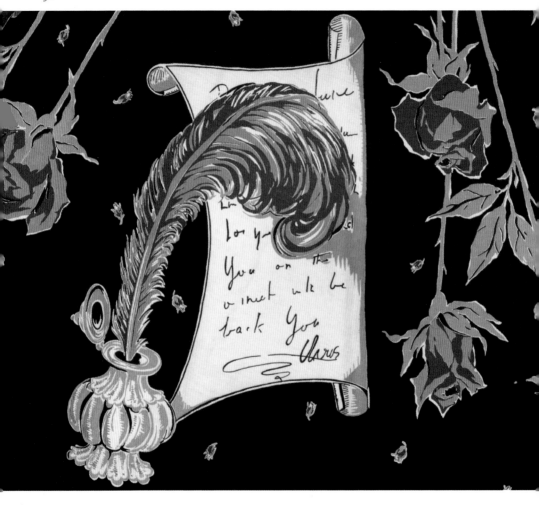

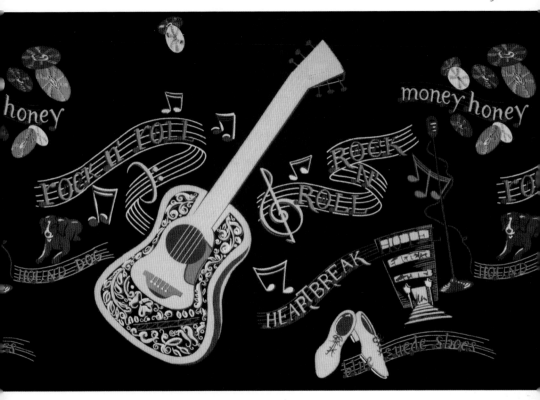

Left: Stylized roses were a popular motif of the 1950s, implying romance and an elegant ladylike charm, seen here on the details from a circular skirt charting the progress of a literary love affair.

Above: The 'new' teenagers demanded their own style of clothes. Tthe circular skirt was an essential element of the teenager's wardrobe. This one describes the popular rock 'n' roll hits of American singer Elvis Presley.

Right: The fabric for a circular skirt provided enough surface to portray a plethora of scenic images and novelty motifs. This one is inspired by all things maritime – from shells to spinnakers.

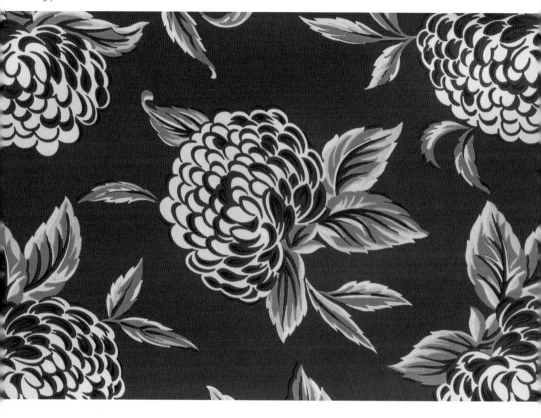

Above: Print designs of large-scale tropical and exotic blooms were representative of a booming post-war tourist industry and the manufacture of resort wear such as sarongs and halter neck tops.

Right: 'Patio prints' were large-scale floral designs on a heavyweight cotton cloth called 'bark cloth', owing to its rough-textured surface. More refined fabrics were scarce even after the war and colourful prints made bark cloth more acceptable.

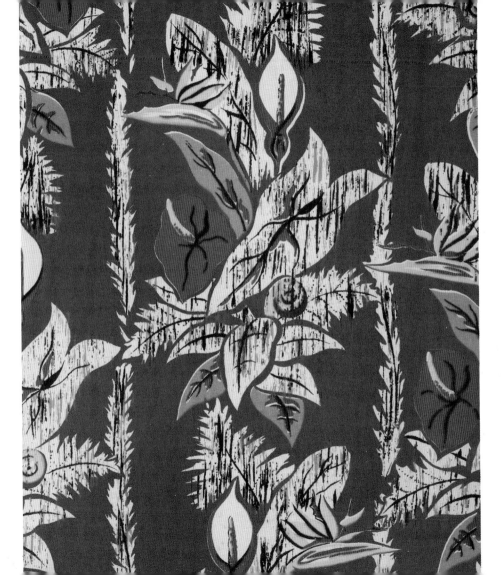

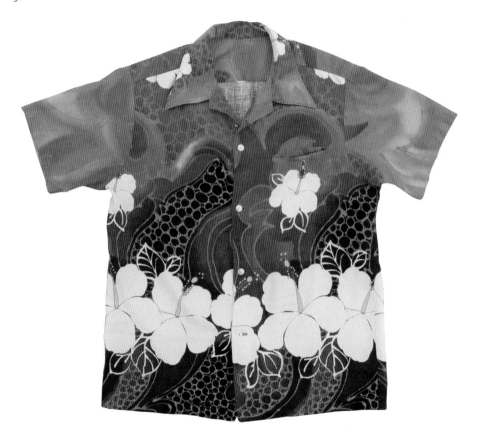

Hawaiian shirts began to be made in the 19th century in an attempt by Christian missionaries to clothe the naked islanders. Patterns were originally adapted from old designs on tapa cloth, the indigenous fabric made from the bark of the wauke plant. By the 1930s there was a flourishing souvenir shirt industry, popular with the armies that were stationed on the islands during and after World War II. This one is from the Flora & Fauna label.

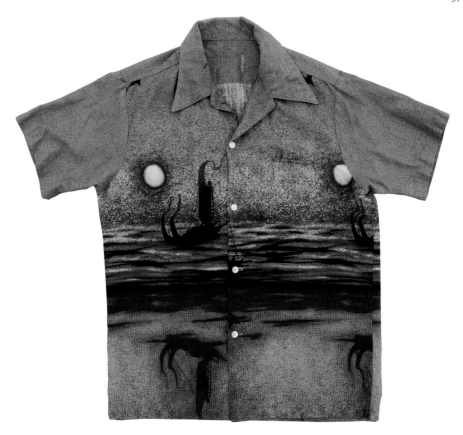

Opposite page: This large-scale floral design of white hibiscus floating on a sea of curving foam gains flamboyance from the background of a contrasting spectrum of sunset oranges and reds.

Above: A cocktail of tropical colours in this green nocturnal seascape with sultry orange foreground form this engineered print; that is one that is printed to fit the pattern piece, rather than a length of cloth.

Below: An all-over print design from an Hawaiian shirt. By the 1950s, the designs on the shirts were no longer restricted to their earlier Polynesian symbolism and a simple reference to palm trees confirmed the genre.

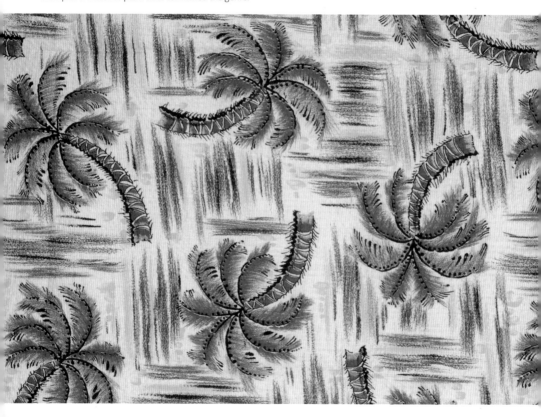

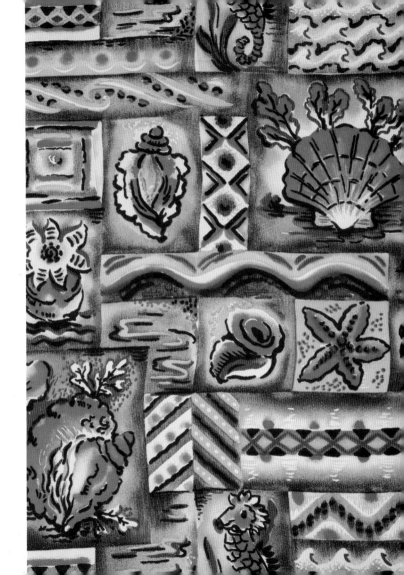

Right: An American fashion print for resort wear conveying the iconography of the seaside, with starfish, coral and the ever popular shell motif.

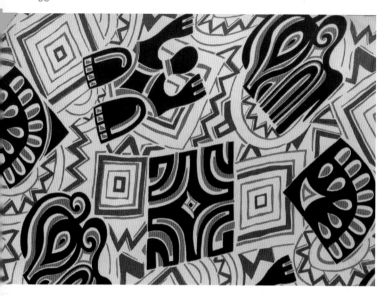

Above and right: Two fashion fabric prints for resort wear, featuring motifs inspired by a Western interpretation of Pre-Columbian art for the tourist trade.

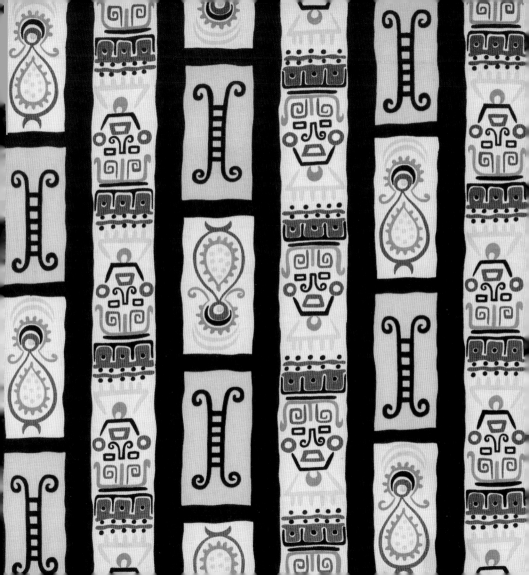

Right: Pagodas and flowers in this light-hearted fashion fabric design on artificial silk – 'shantung type' – in various colourways from the print production and sampling archives of British Celanese.

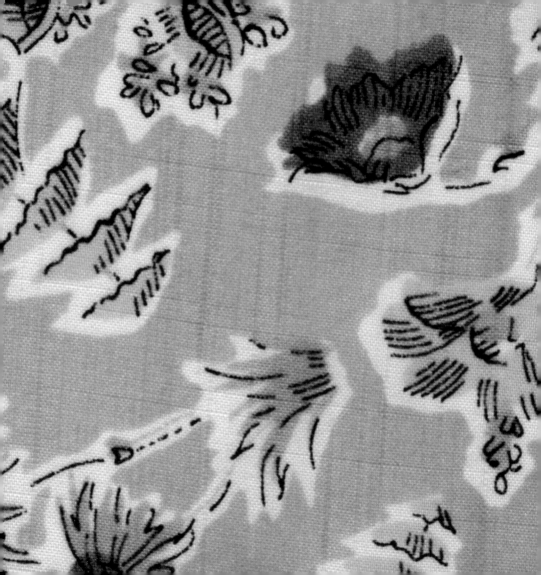

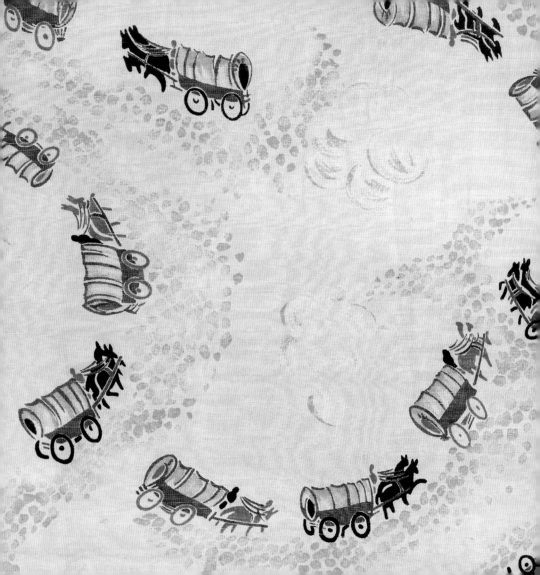

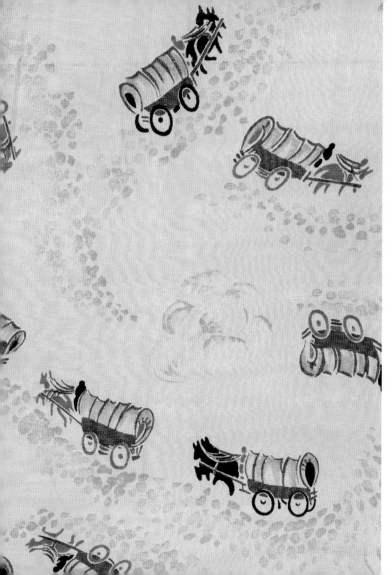

Left: The proliferation of images drawn from America's Wild West during the post-war period reflected the popularity of the genre in film and TV programmes, here featured on a 'juvenile' print on cotton.

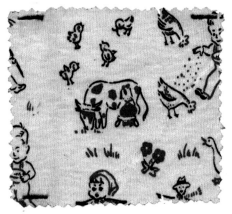

Left: A pigment print on interlock jersey, designed specifically for children by British Celanese, depicting farmyard animals.

Left: A folkloric fashion print with a stereotypical view of Europe in this design for children by British Celanese, depicting tulips, windmills, clogs and Chianti.

Right: A children's dress fabric printed with simple two-colour line drawings of stylized flower posies and ponies.

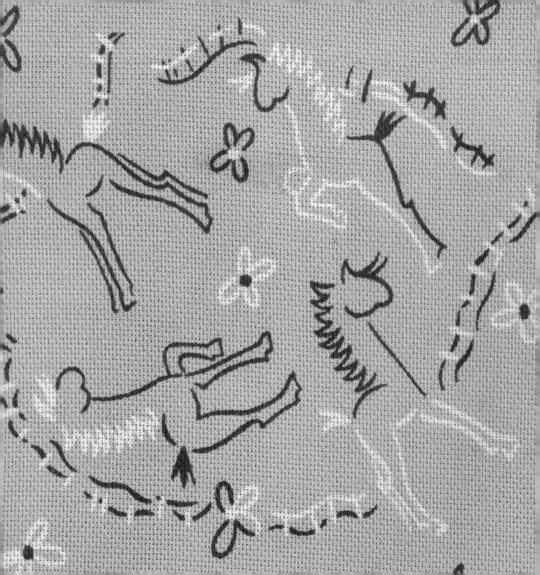

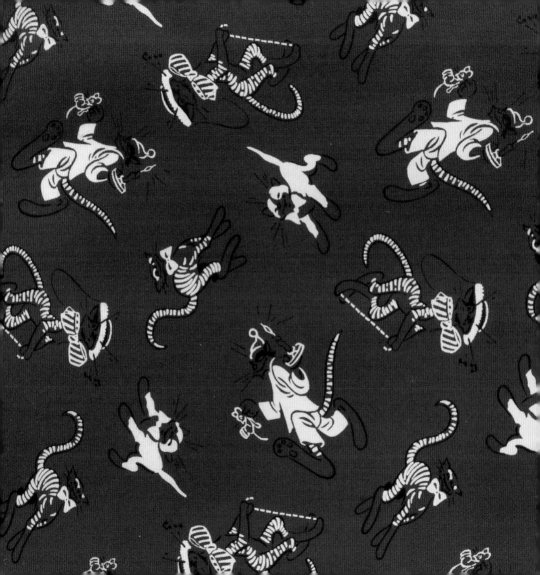

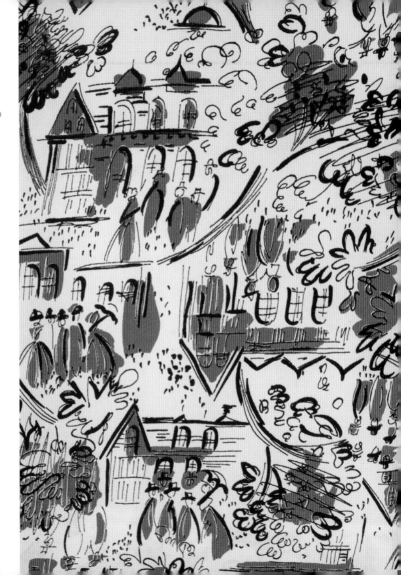

Left: A non-directional design is one that has no top and bottom, or right and left, and is therefore economical to use as a fashion fabric. This design of frolicking cartoon cats featured in a wittily named design for a children's product, *The Katz Pyjamas*.

Right: A fashion fabric featuring loosely sketched images of people and buildings enlivened by areas of a single solid colour.

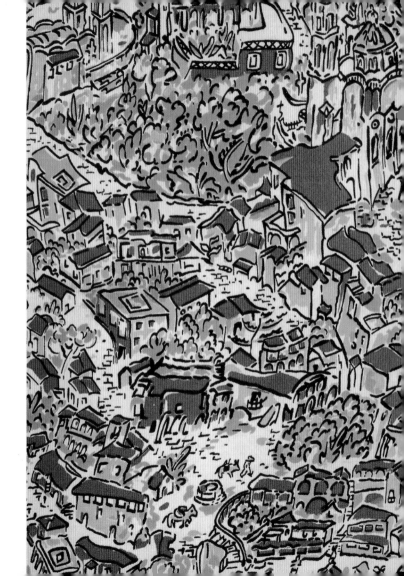

Right: A topographical drawing of a South American village is rendered three-dimensional by the all-over pen and ink drawings and the idiosyncratic detailing that allows for no background.

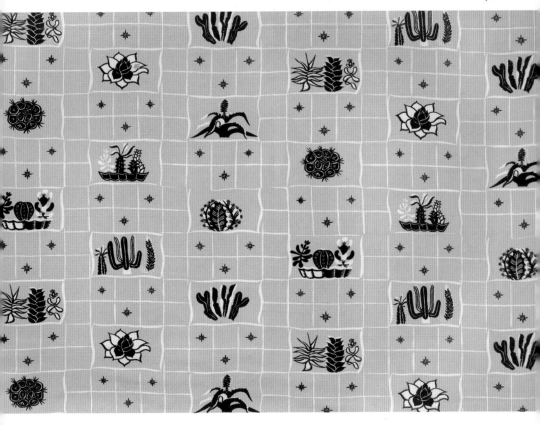

Above: Bringing the exotic into the domestic interior, this kitchen curtain fabric features various cacti positioned in a half-drop repeat within a free-drawn grid.

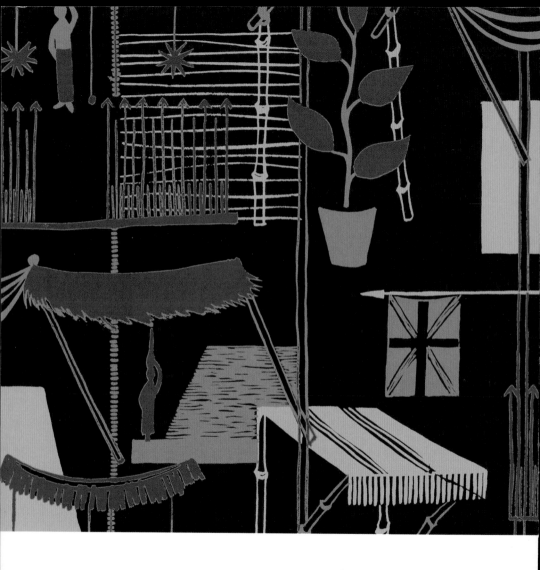

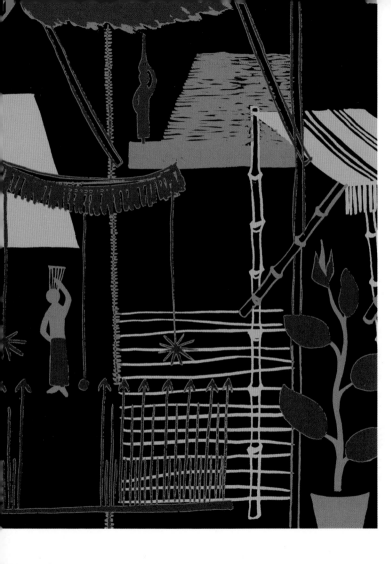

Left: The dark background and the use of acid yellow invest *Penang* by Sylvia Chalmers with the exotic tones of the subject matter. The large scale repeat size is 61.31cm (24in) in width and 30.28cm (12in) in height.

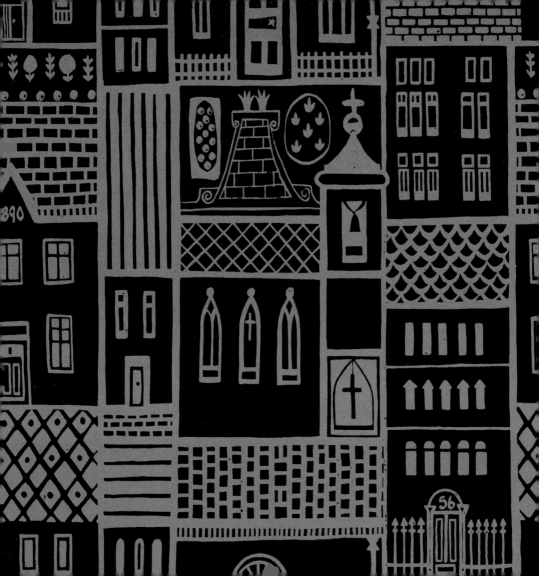

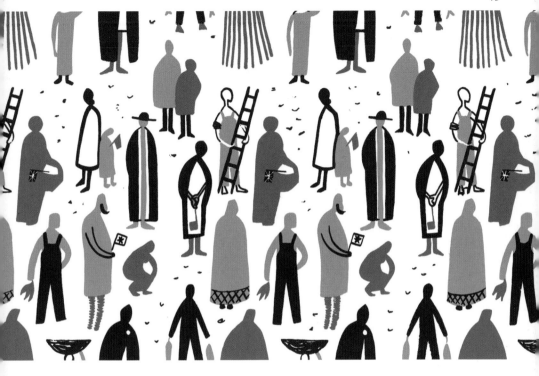

Left: *Village* by Sylvia Chalmers. Domestic architecture features in this single colour, one-directional furnishing fabric design measuring 44.6cm (17½in) in width and 30.55cm (12in) in height.

Above: Observational or whimsical rendering of people was a common thread in 1950s print design. People are rendered in simplified form in this design *Uno* by Sylvia Chalmers. The repeat size is 62.69cm (24¾in) in width and 30.55cm (12in) in height.

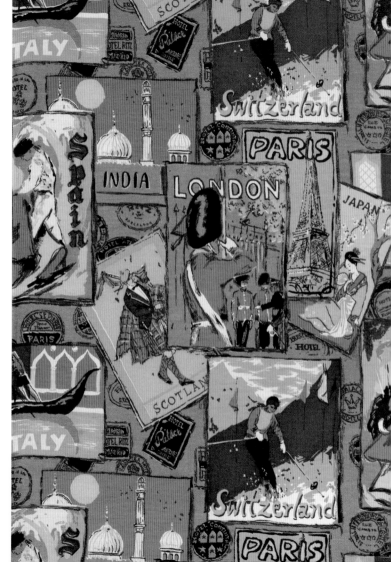

Right: Luggage labels were a popular feature of textile design, implying the sophistication and glamour of the seasoned traveller.

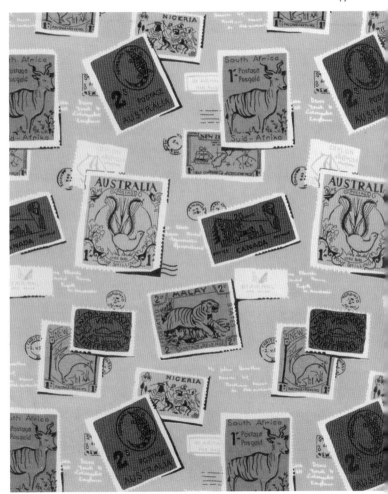

Right: An evocation of Britain's colonial past in this collection of stamps from the British Empire is worked into a block repeat for a fashion fabric. The graphic treatment of dropped shadows gives a strong sensation of dimensional recession.

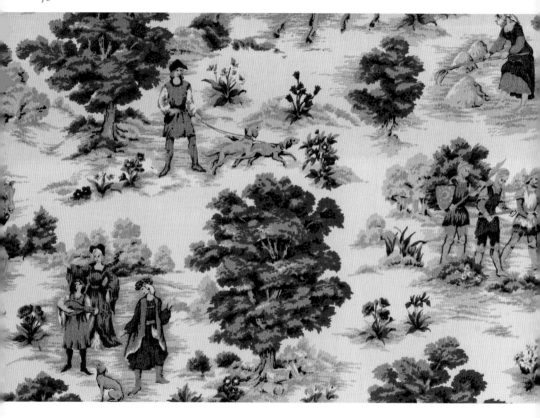

Above: A scenic pictorial print design in imitation of a woven medieval tapestry that reflected the post-war romanticism for England's pastoral heritage.

Right: The first scenic print designs, *toiles*, originated in 18th-century England and France. This American version shows holiday venues within a lush boundary of foliage and flowers.

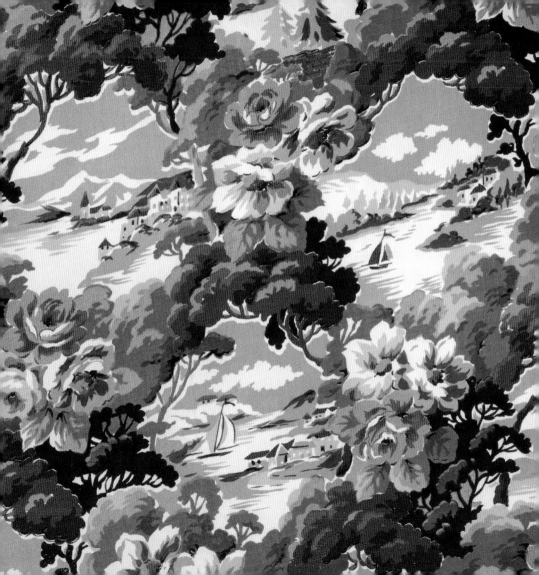

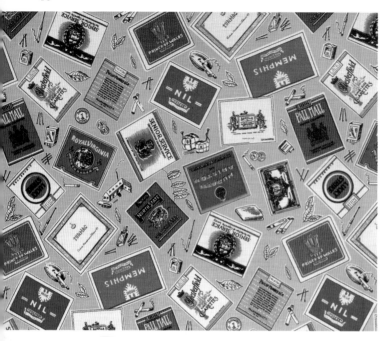

Above: Removing everyday objects from their context and placing them in a repeat design was a useful device undertaken by the designer, as in this fashion fabric featuring cigarette packets from a variety of countries.

Right: The fairground was one of the few venues to offer loud music and entertainment to the 1950s teenager, as seen in this simple banded one-directional furnishing fabric design.

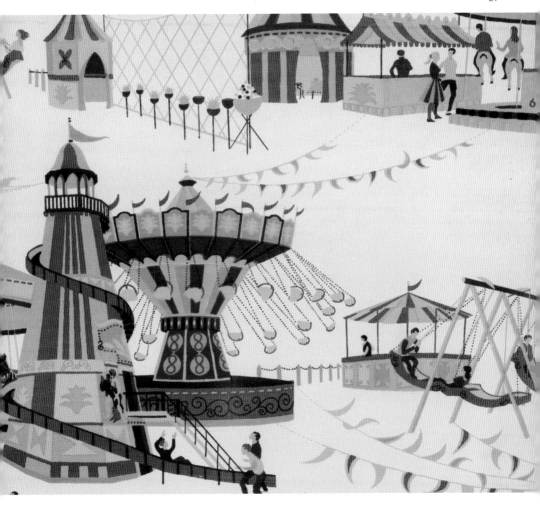

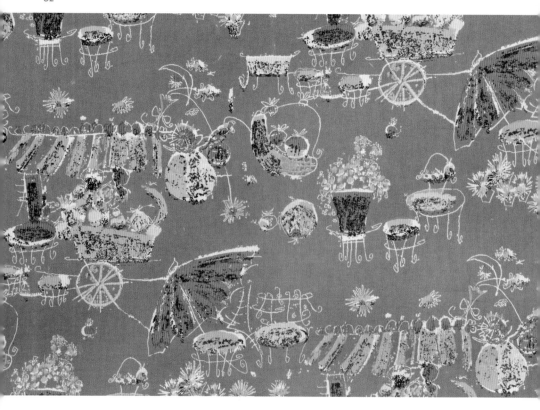

Above: A lightly sketched scene of street furniture and flowers evokes the streets of Paris in this print design for a fashion fabric. The illustrative style has resonances of the drawings of Jean Cocteau.

Right:. The coronation of Queen Elizabeth II resulted in a plethora of souvenirs, one of which was the headscarf in a commemorative print.

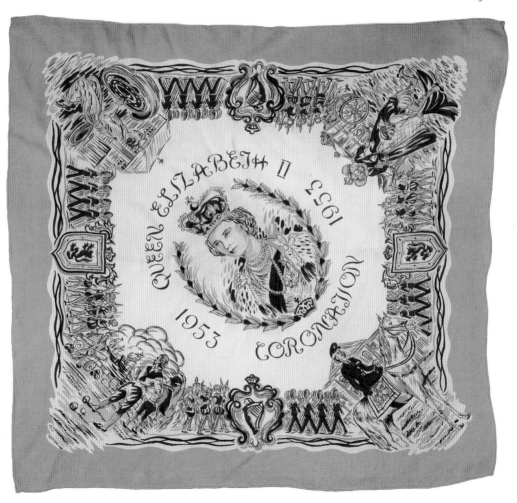

QUEEN ELIZABETH II

1953

1953

CORONATION

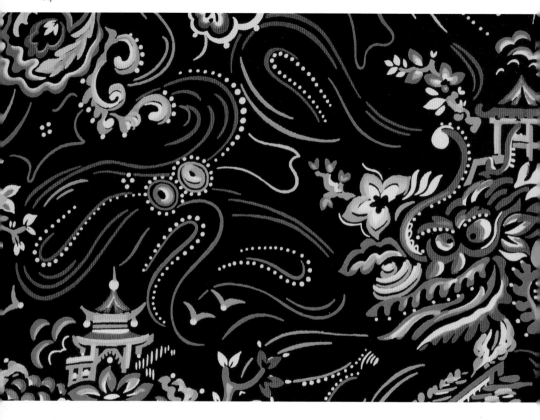

Above: Chinoiserie is a constant theme in the textile print repertoire. It perpetuates the stereotypical images of Chinese culture with pagodas, fire crackers and dragons.

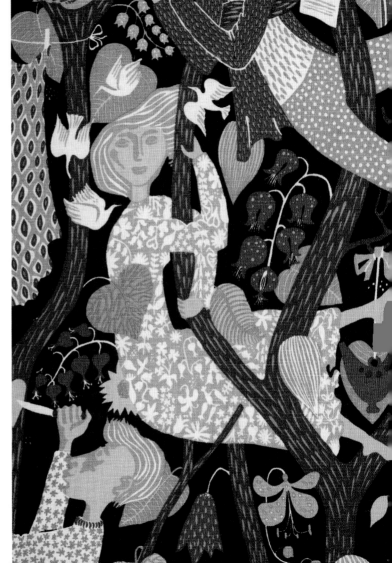

Right: Whimsical imagery is used in *Lustgarden* by Swedish designer Stig Lindberg for Nordiska Kompaniet Textilkammare, a Swedish textile design studio set up by the Swedish department store Nordiska Kompaniet from 1937 to 1971.

Artistic Licence

Fine art is a basic constituent of the textile designer's vocabulary. In the 1950s fine art relinquished representation and realism for the free-form mark making of Abstract Expressionism practised by Jackson Pollock and Willem de Kooning. As James De Holden Stone confirmed, 'there is a growing obsession with the unrehearsed, the totally spontaneous. The expedient of blindfold drawing is producing marks, stains, smudges and other assaults on the paper.' These 'assaults on the paper' resulted in textile designs that imitated the artists' dripping or splashing the paint onto the canvas. Printing provided a mechanical reproduction of the artist's spontaneous activity in which accidental patterns and textures were achieved by splashing, slapping or dribbling paint onto a flat surface.

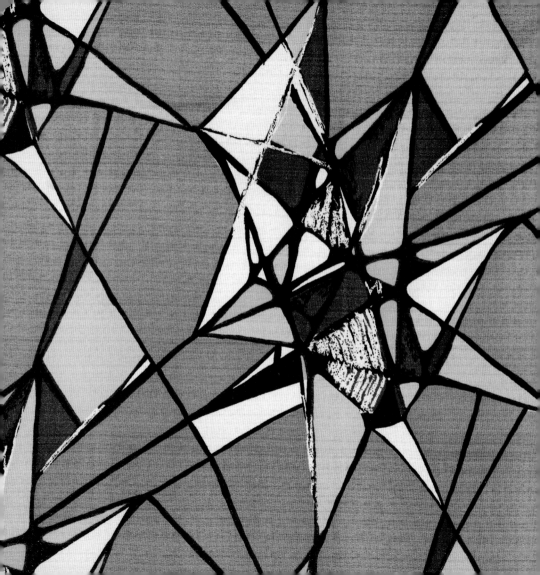

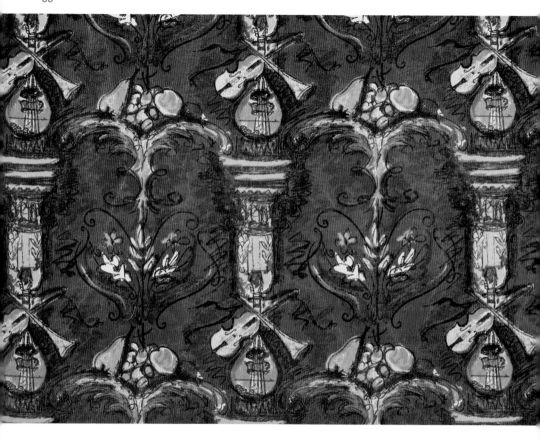

Previous page: *Shattered Glass,* an in-house design by the David Whitehead Studio. The kaleidoscopic fragmentation suggests vibrant interaction between colour blocks.

Above: This loosely rendered block repeat of illustrative marks uses the florid extravagance of garlands, musical instruments and fruit.

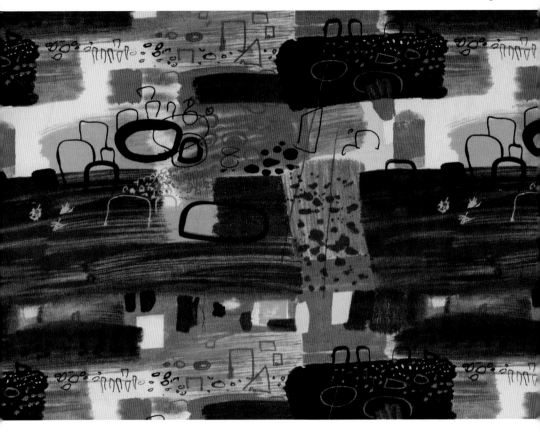

Above: During the 1930s British artist and printmaker John Piper abandoned abstract art for a more romantic portrayal of landscape and architectural scenes. This design, *Finistere*, although produced by David Whitehead in 1969, is more representative of the previous decade's aesthetic.

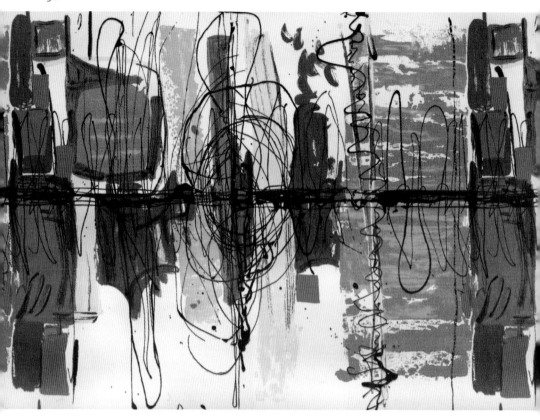

Above: David Whitehead Ltd built up to a fully mechanized screen printing by the late 1950s. This process allowed for greater freedom of expression, producing designs the reflected the free-form mark making of the abstract expressionist movement.

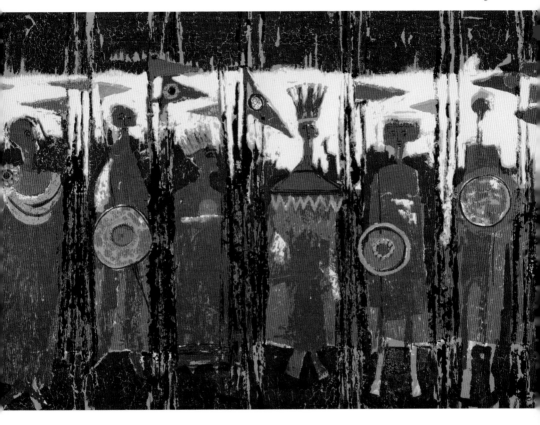

Above: Tibor Reich established Tibor Ltd in Warwickshire, which was renowned for large-scale textiles for public spaces, such as this piece for the Shakespeare Centre at Strafford-upon-Avon by Pamela Kay .Entitled *Age of Kings,* it was subsequently produced as a furnishing fabric.

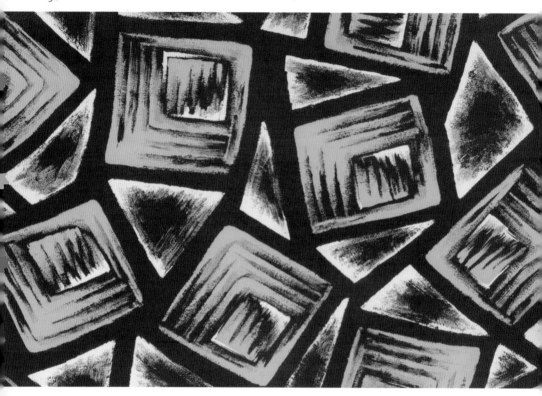

Above: Roughly described tumbling squares of colour jostle within a solid outline to produce a multi-directional design for furnishing fabric. The sense of motion and depth is reinforced by the use of loose parallel strokes within the squares.

Right: A more geometric and structured approach to pattern making, in keeping with modern architectural spaces, replaced the earlier preoccupation with figured abstraction. There is a reference to the work of Anni Albers and the Bauhaus.

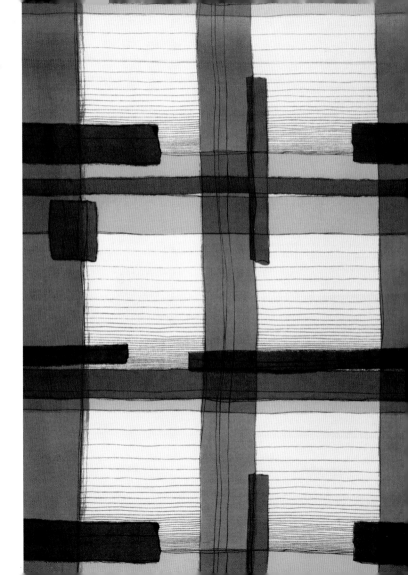

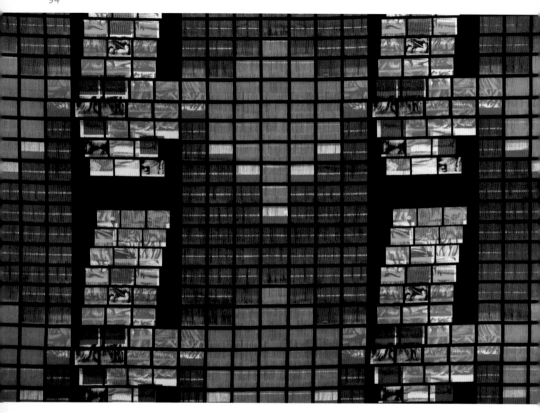

Above: *Rutescent* by Roy Britton for David Whitehead Ltd exemplifies the designer's concern with the manipulation of basic shapes and the tonalities of colour within space. Using a mosaic method, he achieves looseness within a formal grid system by fragmenting previously patterned paper.

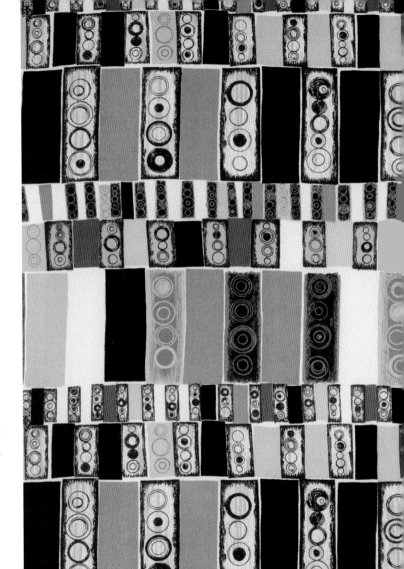

Right: *Traffic Lights* designed by Czech-born Jacqueline Groag in 1953 for David Whitehead Ltd is roller printed on rayon. The sturdy blocks of colour and emphatic patterning reflect the designer's previous experience working for the Wiener Werkstatte.

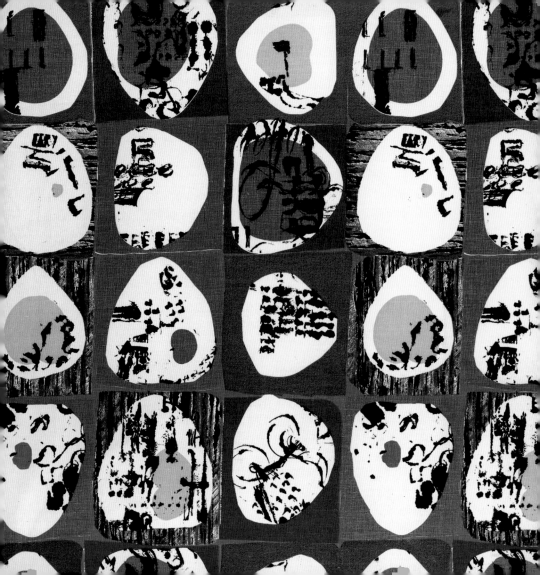

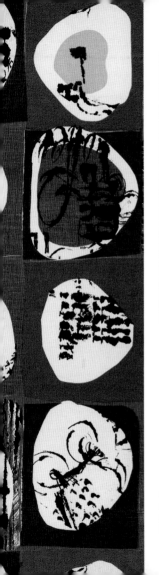

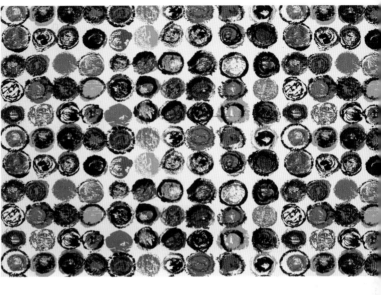

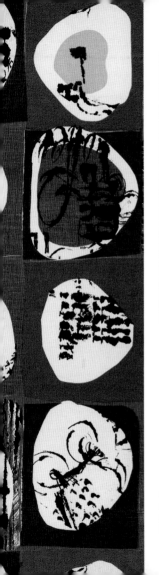

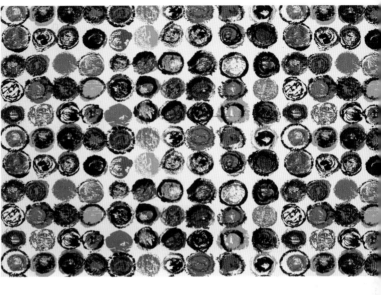

Above and left: *Ducatoon* designed by Lucienne Day in 1959 was roller printed in five colourways. The designer deserted her usual practice of drawing in pen and ink on a painted gouache ground and deployed the art of mono-printing for the black painterly marks in this design for Heal Fabrics.

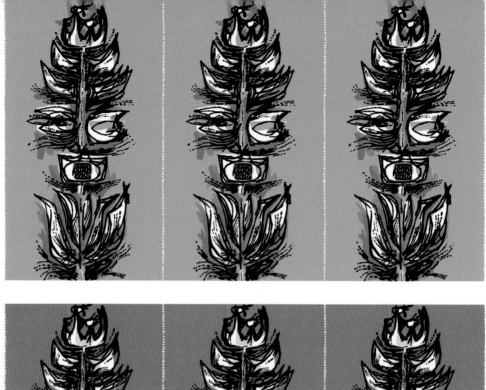
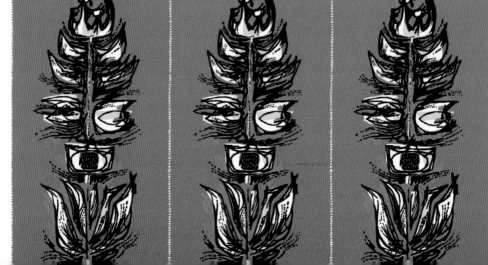

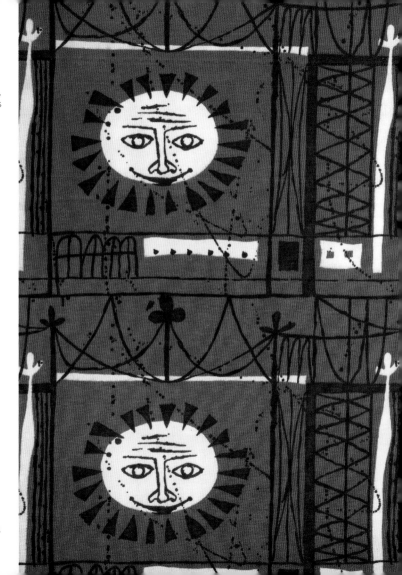

Left, top and bottom: *Ardorange* designed by Robert Stewart in 1954–55, a screen print on linen, exemplifies the designer's bold graphic style. Stewart was also an influential educator as Head of the Printed Textile department at the Glasgow School of Art from 1948 to 1984.

Right: *Sun Man* by Robert Stewart, 1953–4, appeared on various products, including a Liberty waste paper container. He produced more than 130 in the 1950s, including furnishing fabrics, scarves, cushion covers, tablemats, wall hangings, embroideries and tapestry.

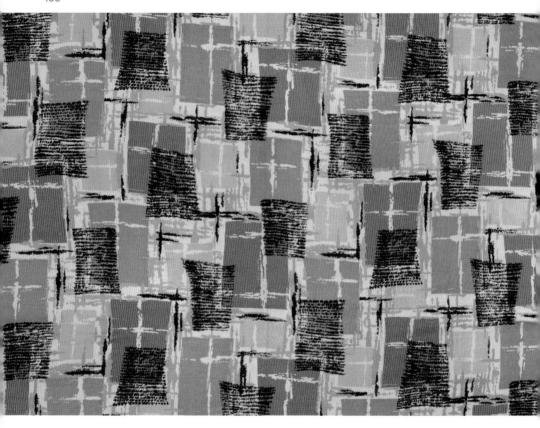

Above: Squares of roughly sketched lines are overprinted on solid blocks of colour in this multi-directional furnishing fabric design, which loosely recalls the geometry of the popular Argyle checks.

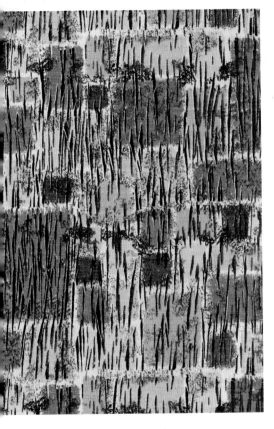

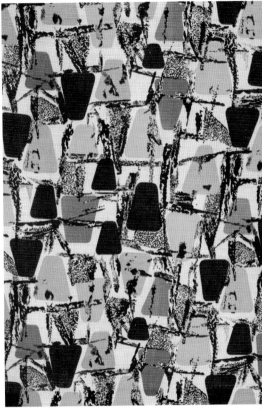

Above: The strong vertical marks give the illusion of a thick-stranded cloth showing through the print to create a heavily textured surface in this design for furnishing fabric.

Above: The modular-shaped motifs, that is, rectangles with rounded corners, are rendered in solid colours of various tones, juxtaposed with seemingly spontaneous dry brush strokes or mono-printing effects in black.

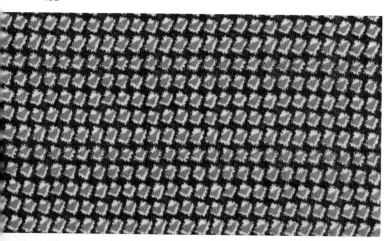

Left: Although at first glance this print from the archives of British Celanese appears simple and mechanical, the motifs are minutely disturbed, rendering the design animated and organic.

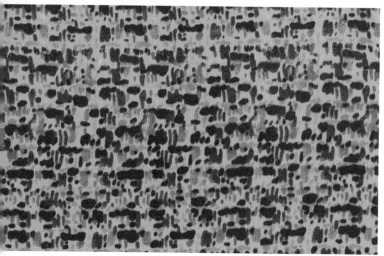

Left, right (top and bottom): Accidental patterns created by seemingly random splashes of colour printed on a textured woven cloth in these three designs from the British Celanese archives.

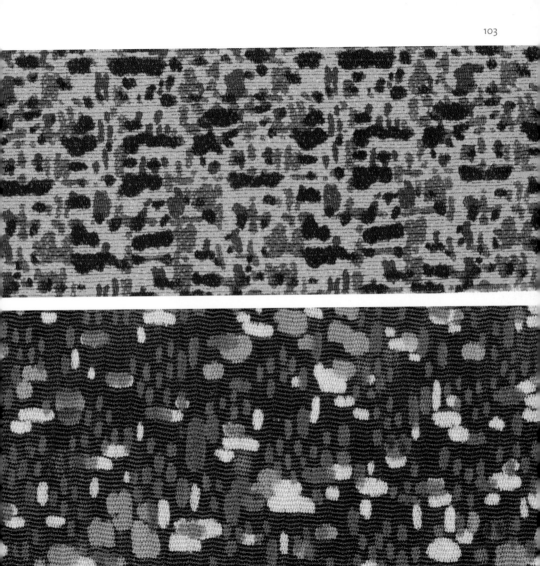

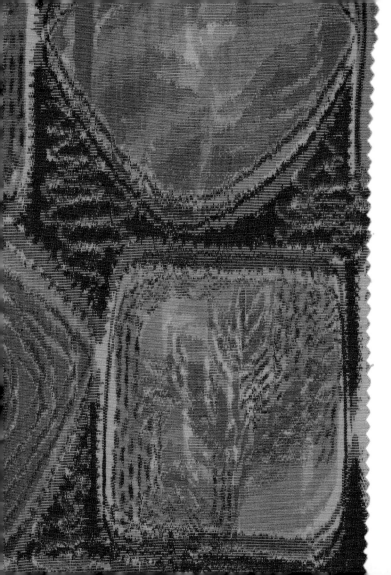

Left: A warp print is one where the warp (the lengthwise thread) is printed with pattern before the weft is woven across it, resulting in a motif that has a blurred, softened outline, a type of fabric also known as shadow tissue. This warp-printed sample from the archives of British Celanese is a mass-produced example of this.

Below: A fashion fabric design on glazed cotton chintz featuring loosely painted squares and ellipses.

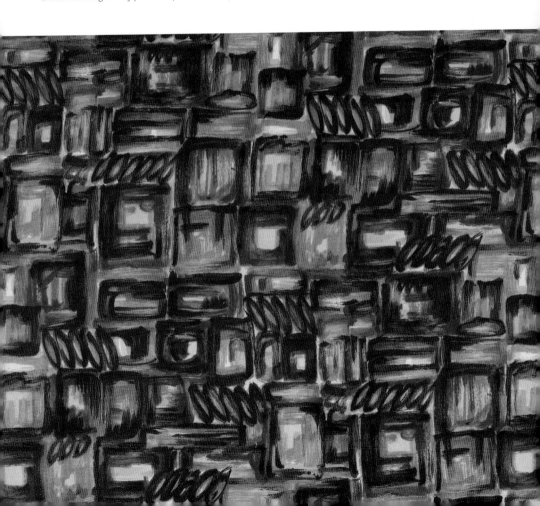

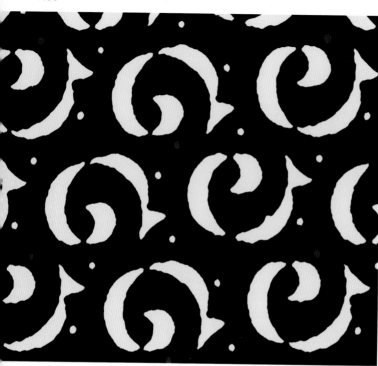

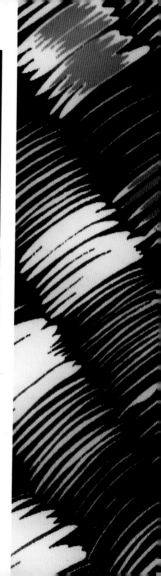

Above: The diagonally drifting scroll forms in this simple design are anchored into equilibrium by the highlight red spots in a diamond framework.

Right: Dramatic discharge print, with red flourishes. The animation of the hatching adds a depth and vitality to the repeat.

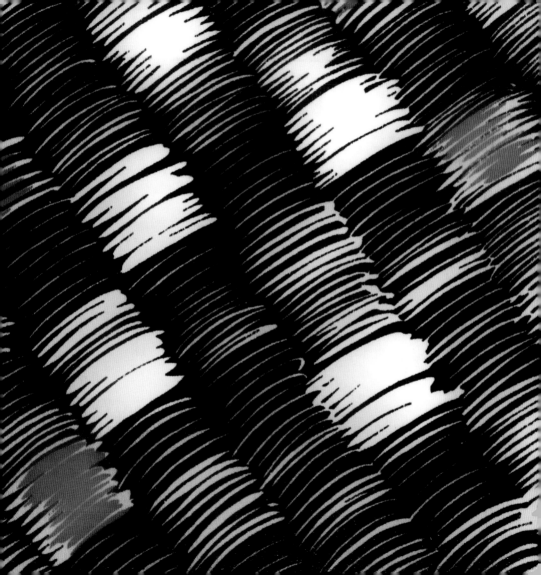

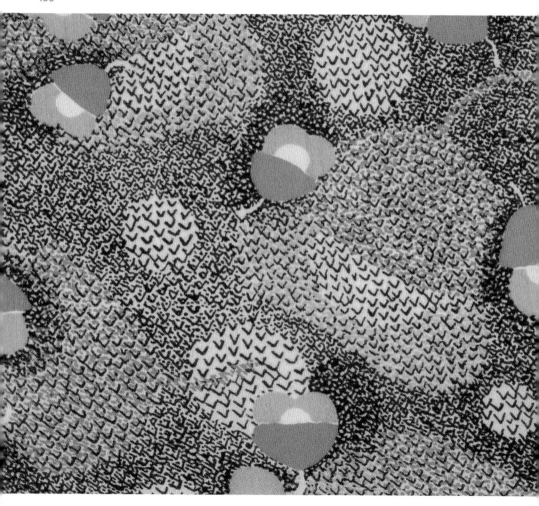

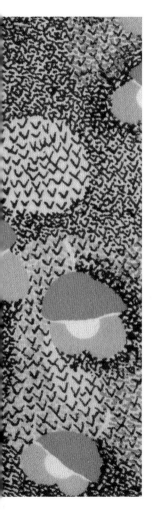

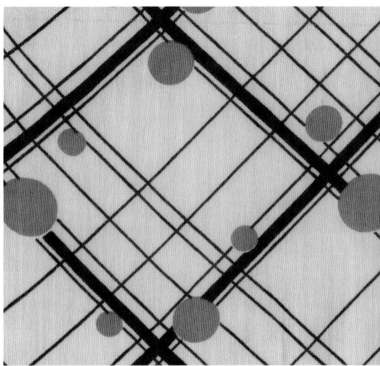

Above: This free-drawn linear check is combined with an equally loose polka-dot repeat to create an open vivacity in this informal dress fabric from the archives of British Celanese.

Left: Seurat meets solid in this complex three-colour dress print. The enlarged crepuscular floral forms of the background drift behind crisply focused miniature replicas in the foreground.

Kinetic

The energetic and fast-moving 1950s – a period of transition from the post war years to the coming of the jet age – was reflected in the paintings and sculpture of the era. Kinetic art depended on motion for effect, most particularly with the introduction of Alexander Calder's mobile. The American sculptor invented the mobile in the 1930s, but it was not until the 1950s that the device entered popular consciousness. The mobile had a friendly accessibility, lending itself to the domestic interior and even becoming a popular do-it-yourself exercise. Usually consisting of abstract shapes in bright primary colours these seemingly fragile, delicate three-dimensional forms with interdependent arms influenced all aspects of design, from tubular steel and wire-product design to the applied arts.

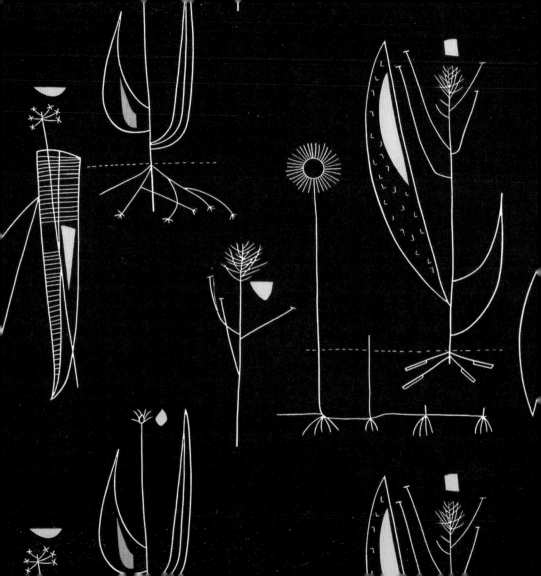

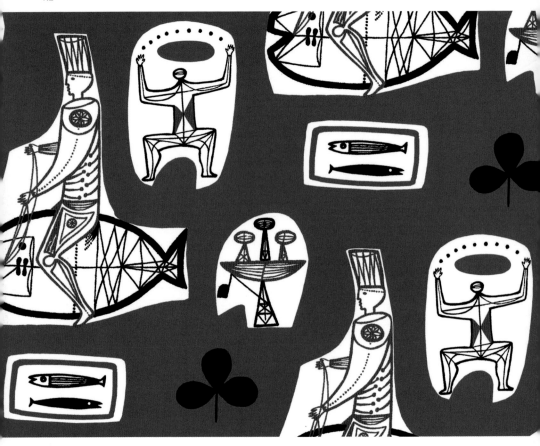

Previous page: *Herb Antony* designed by Lucienne Day (using a fine-nibbed pen) for Heal's in 1956. The quirky images are homage to the painter Joan Miro. The print was realized with the discharge method.

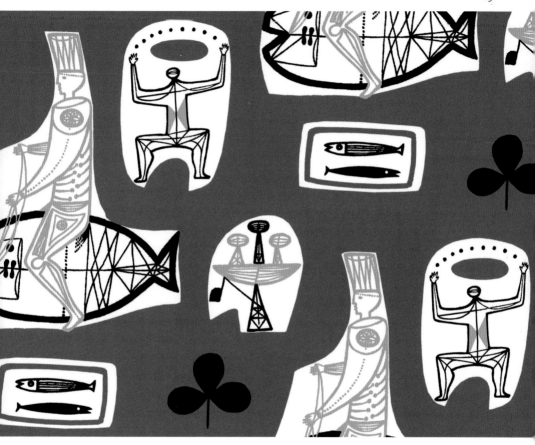

Left and right: Robert Stewart was the designer instrumental in the 'rebranding' of Liberty as the exponent of contemporary style. This design, *Macrahanish*, is one of the most well known, and was designed in 1954 and produced in roller printed cotton with a 38 cm (15 in) repeat.

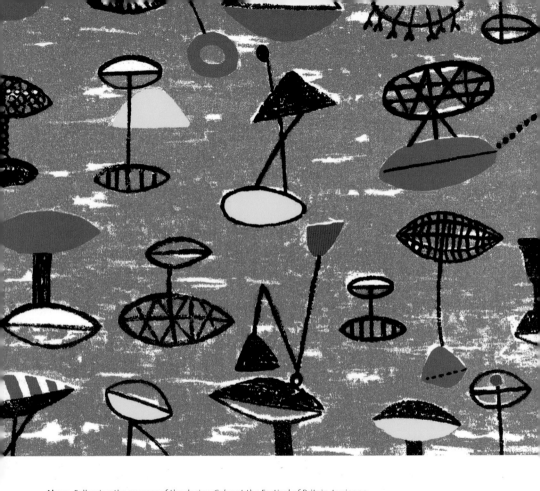

Above: Following the success of the design *Calyx* at the Festival of Britain, Lucienne Day was asked to design a similar print but with a smaller repeat, more suitable for domestic interiors. *Flotilla* was designed in 1952, referencing the influence of the work of artist Paul Klee..

Right: The ubiquitous shape of the boomerang is here rendered more static by forming a closed motif as an irregular stripe. Designed by Marian Mahler for David Whitehead Ltd in 1952.

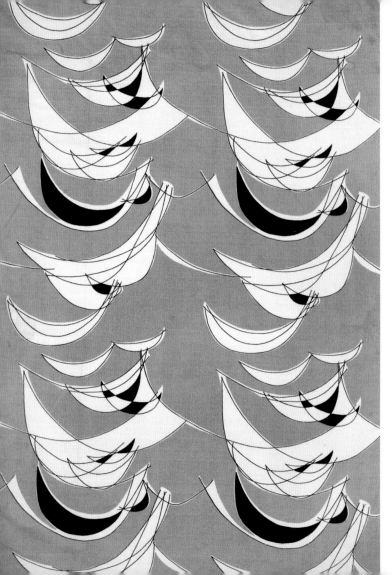

Left: The parabolic arch and the deliberate asymmetry of the motifs in this unnamed design are open to interpretation – sailboats, birds or a choppy sea.

Right: *Raimoult* was designed by Robert Stewart for Liberty of London in 1955. It appeared in four colourways and had a 66 cm (26 in) repeat pattern. The clover leaf motif was one used frequently by Stewart. Here it is scattered randomly over a sea of abstract shapes, suggesting flotillas of sailing boats.

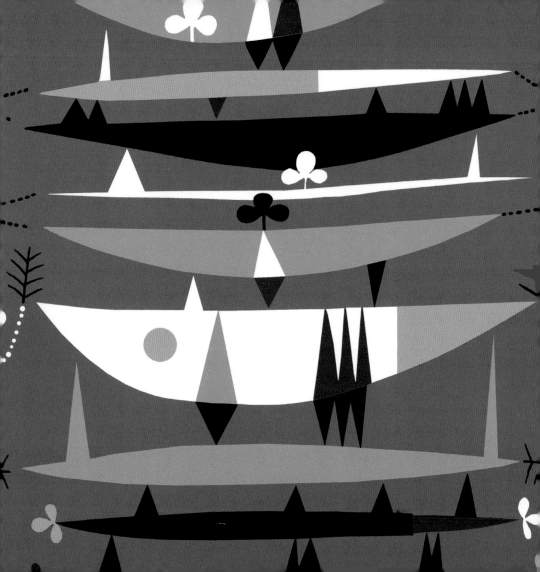

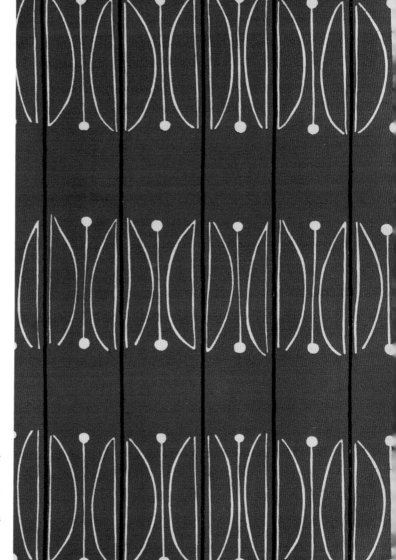

118

Right: A molecular motif – a dot at the end of a line or 'spoke' – is an indication that this anonymous design originates from the earlier part of the decade, recalling the Skylon theme.

Below: The rigid geometry of hexagons in tight honeycomb formation is given a looser flow by the fragmenting lines, suggesting electronic circuitry.

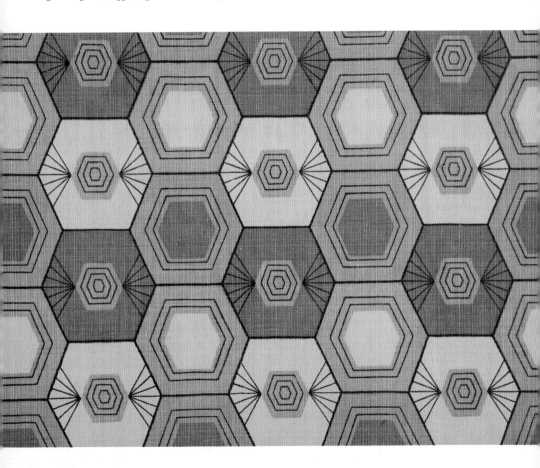

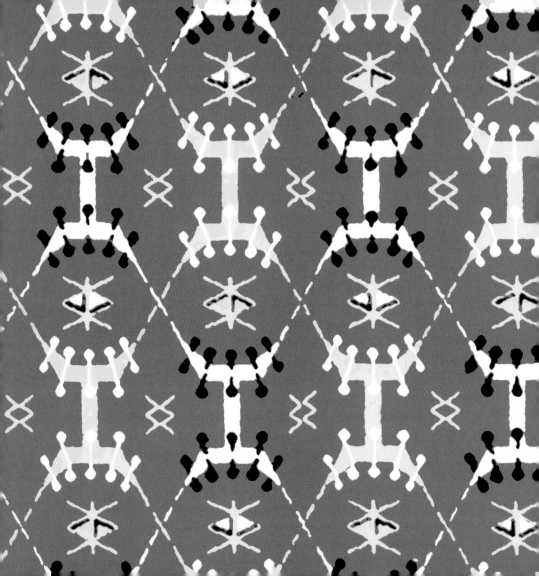

Left: The hexagonal framework of this design arises from the interlinking of wave forms that recall the screen of an oscilloscope. Scientific elements provided a source of inspiration for textile designers.

Right: The stiletto heel, the Skylon, the tail fin – all attenuated needle shapes – permeated every aspect of design, including this unbranded futuristic textile design.

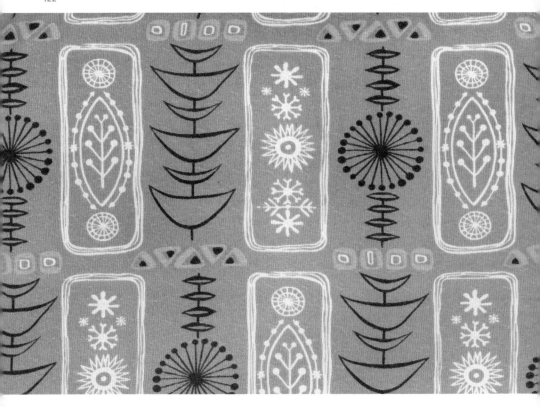

Above: This unbranded furnishing fabric design includes all the signature motifs of the era, the crescent shapes suspended from a fine line, skeletal leaf shapes and the sputnik-style starbursts.

Right: As television emerged into 1950s homes, it generated a more sophisticated awareness of graphics and design. The modular shape of the screen and the triangular spikes of the aerial appeared frequently in textile design, as in this furnishing fabric.

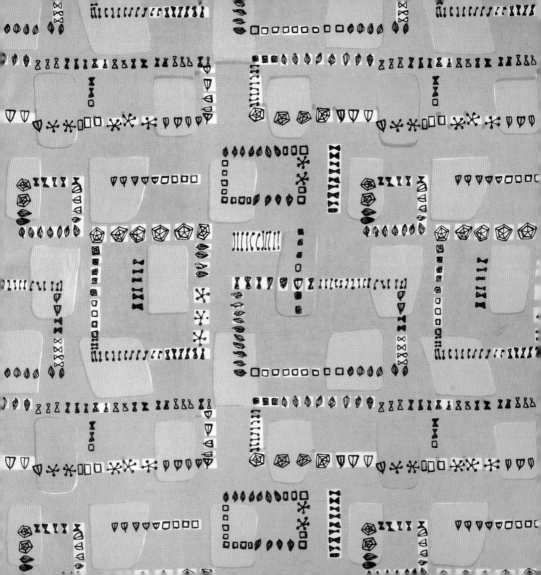

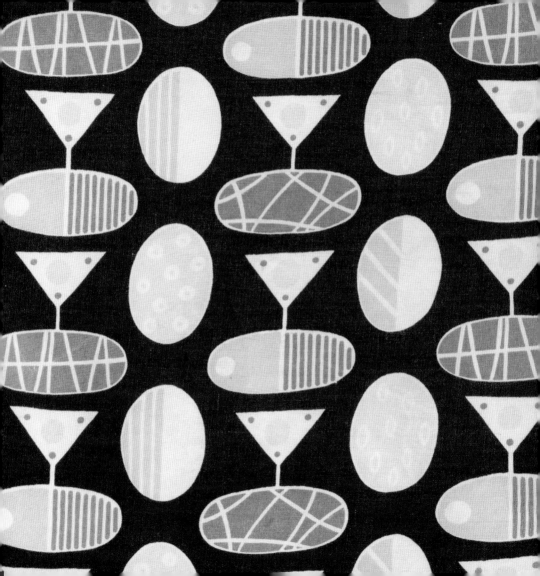

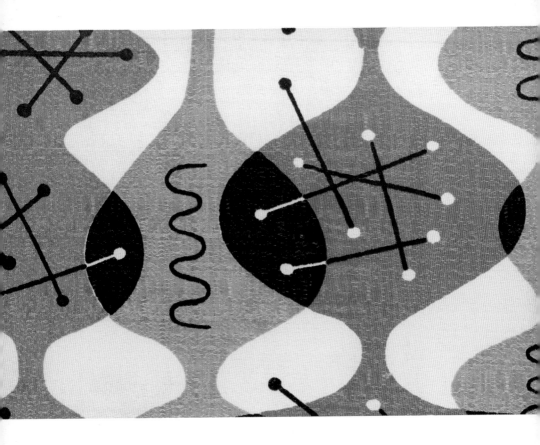

Left: There is the suggestion of cocktail glasses in this anonymous design, floating on a dark background given variegation by a lively set of infill patterns.

Above: An example of a simplified version of the molecular model (the cherry on the stick motif) is scattered on the undulating stripes of this furnishing design by Hertzberger for Rosebank Fabrics.

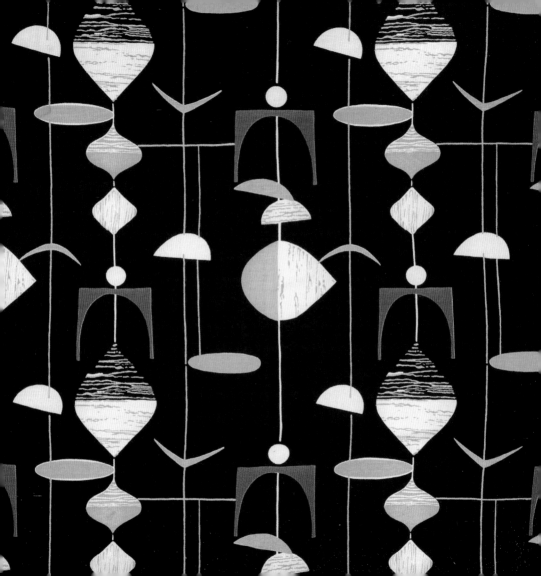

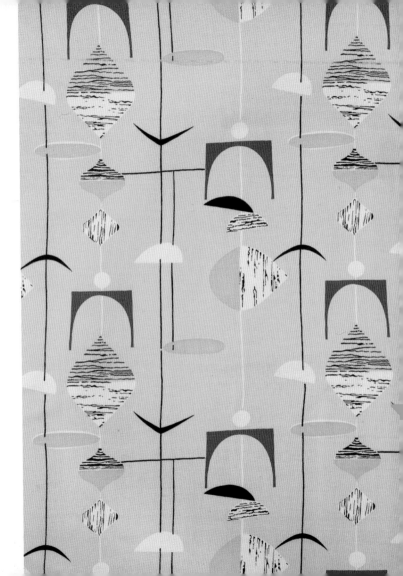

Left and right: Pendant-shaped forms appear essentially weightless in this Alexander Calder-inspired design *Mobiles* by Marian Mahler for David Whitehead Ltd.

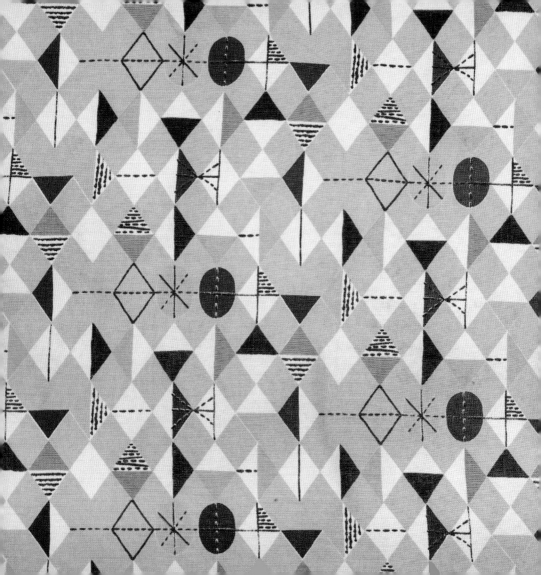

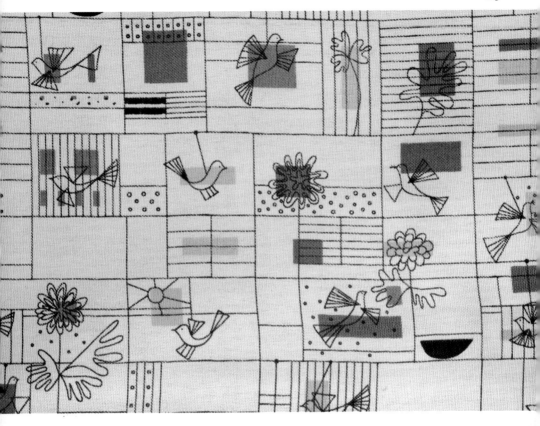

Left: A simple geometric format is loosened by the haphazard colour distribution and overlay of linear components. There are echoes of the Festival of Britain iconography, as well as the abstract paintings of Paul Klee.

Above: The drawn line gives the impression of thin wire twisted into shapes of birds and flowers. The influence of several modern artists is discernible – Joan Miró, Matisse and Picasso.

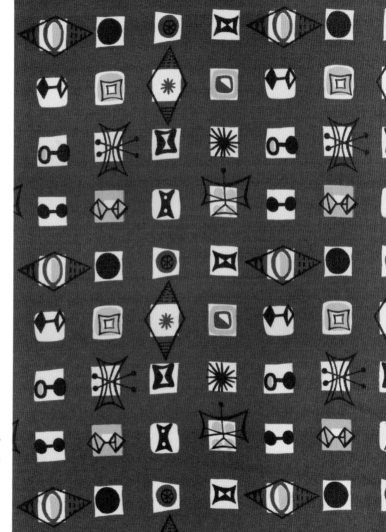

Right: Microscopic crystal diagrams were a source of inspiration for designers, including Marian Mahler, who designed this print for David Whitehead Ltd in 1954. The style went out of fashion in the mid-1950s.

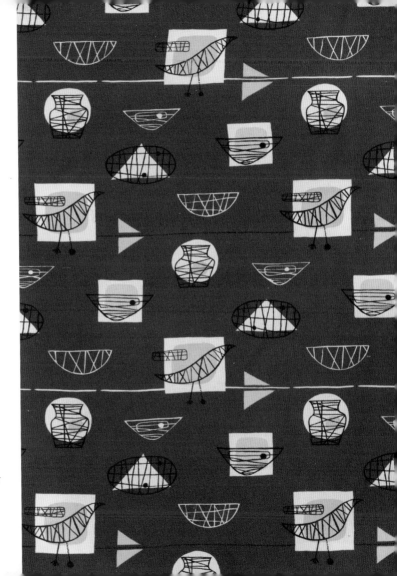

Right: The device of objects seemingly constructed from wire is used to effect in this design by Marian Mahler for David Whitehead Ltd in 1953. Note the abstracted birds feet rendered as finials.

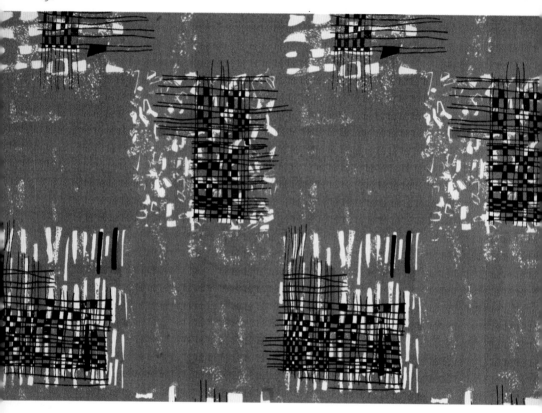

Above: *Quarto* designed by Lucienne Day for Heal's in 1960. The company's most successful designer, Day's name was incorporated into the selvedge of every piece of cloth. By the end of the decade Day had produced 35 designs for Heal fabrics. *Quarto* recalls both Klee and Albers in its use of simple geometry.

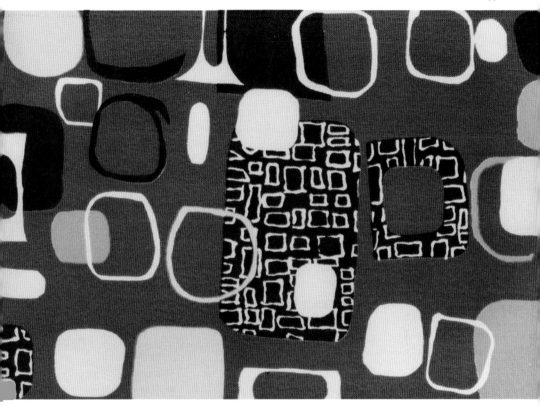

Above: *Abstract Frames and Pebbles*, designed by Jacqueline Groag for David Whitehead Ltd in 1952. Printed onto cotton and rayon using the roller method, the design was intended for the furnishing market, and was also sold to Formica to appear on laminated surfaces.

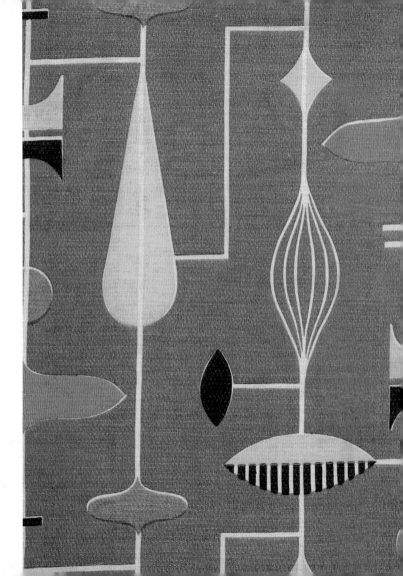

134

Right: The chemistry laboratory and the schematics of wiring diagrams are referenced in this unnamed design, featuring pipes, tubing, retorts and switches in an acclamation of scientific modernity.

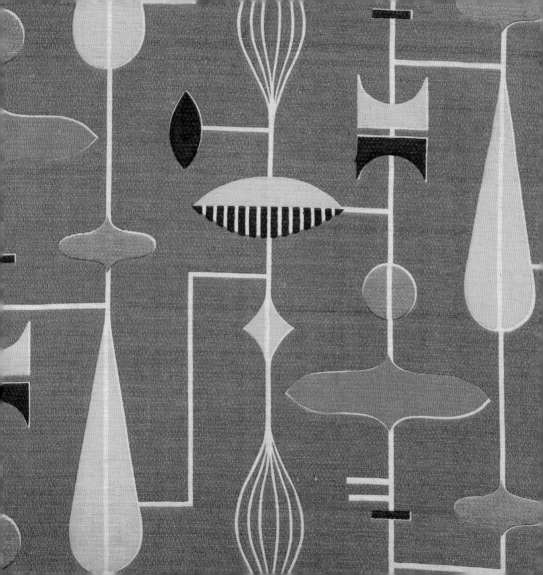

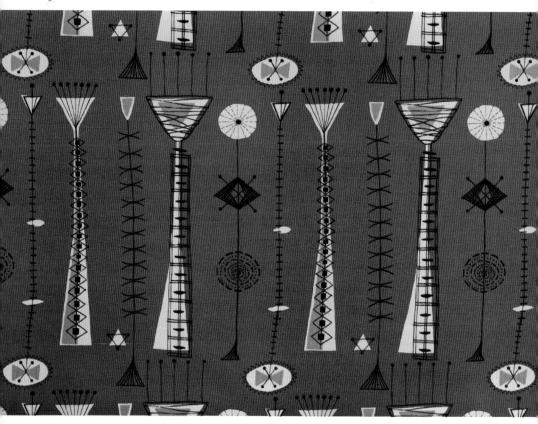

Above: Suggestive of attenuated kites and pylons, *Kite Strings* was created by David Parsons for Heal Fabrics in 1955.

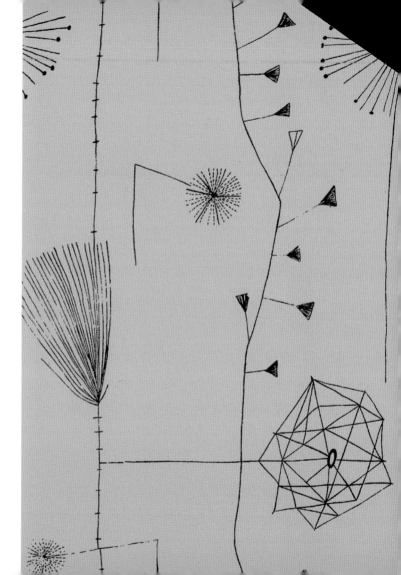

Right: Spidery, fragmented and broken lines reflect the fragility of the subject matter. *Dandelion Clocks* by Lucienne Day was inspired by photographs of dried flowers in the house of designers Charles and Ray Eames.

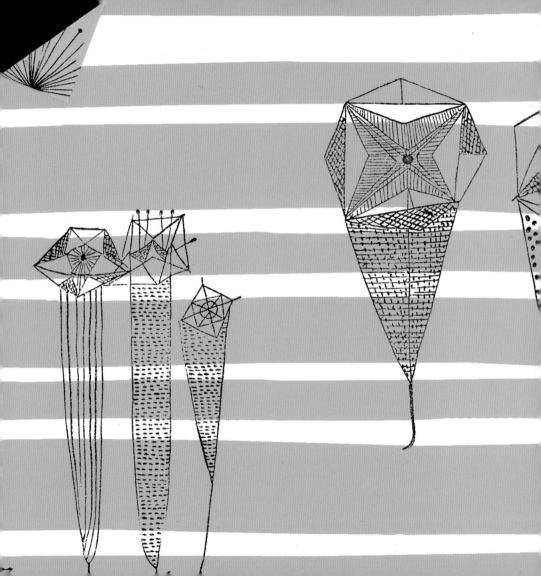

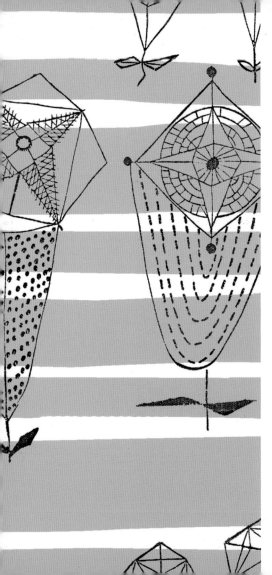

Left: *Trio* by Lucienne Day represents the designer's signature combination of solid stripes or planes of colour overlaid with finely drawn linear motifs that have the impact of shamanistic symbols and tribal scarification.

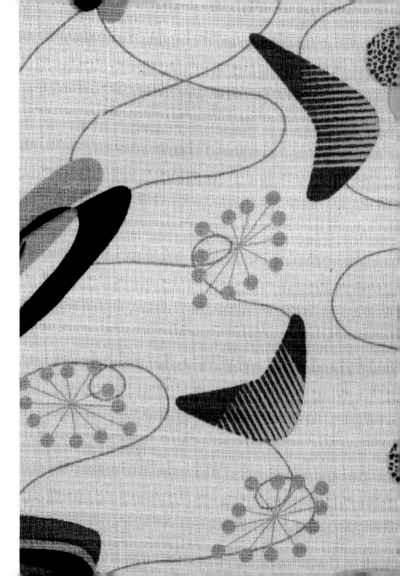

Right: The boomerang shape – its popularity reflecting the interest during this decade in aviation and mobility – was synonymous with 1950s design, here linked together with the cherry-on-stick motif by a finely drawn line.

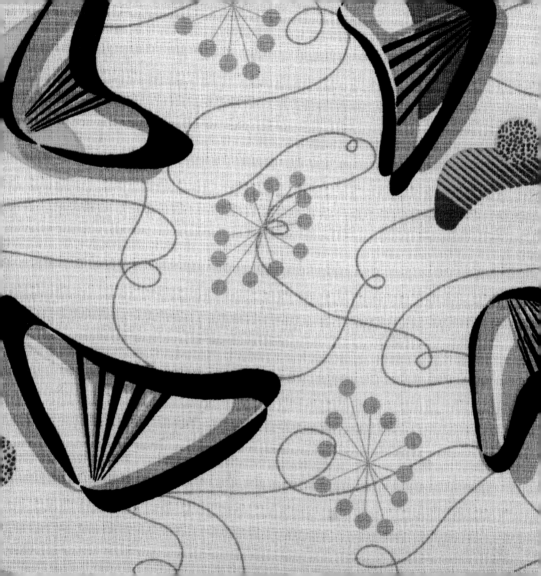

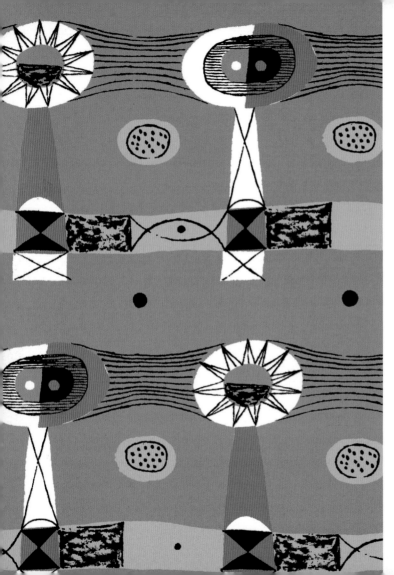

Right: *Magnetic* by Lucienne Day was roller printed on cotton and produced in five colourways. The 1958 design was shown in the Goppinger Gallery, Germany in an exhibition designed by Robin Day.

Left: Designed by Robert Stewart in 1954 *Kilmun* was originally called *Ailsa*. It was hand-blocked on linen and features front and back views of eerie stick-like figures that have the appearance of monolithic figures in a land and seascape

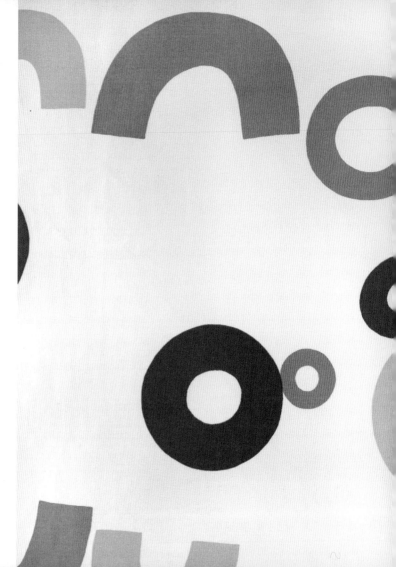

144

Right: Hull Traders was founded in 1957 by Tristram Hull, and was Heal's closest rival in artistic terms, collaborating with artists Eduardo Paolozzi and Nigel Henderson, amongst others.

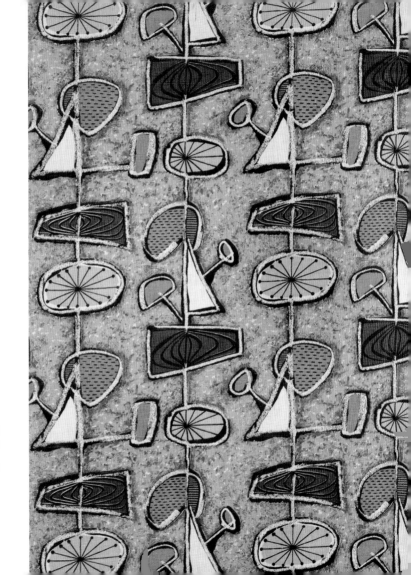

Right: The striped pendular arrangement of this design achieves a balanced all-over effect. All components have the richness of hand-rendered studio treatment and the abstract motifs of cut fruit and vegetables.

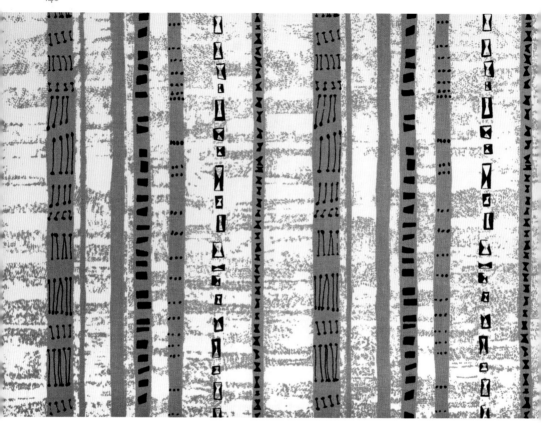

Above: *Ticker tape* designed in 1953 by Lucienne Day for Heal's was jointly awarded a Gran Premio at the Milan Triennale in 1954, alongside *Linear, Spectators* and *Graphica.*

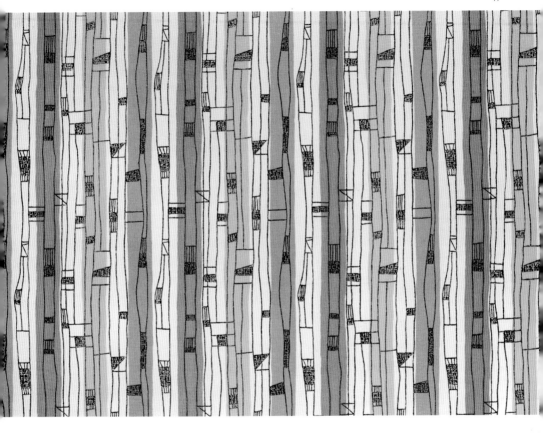

Above: A design by Lucienne Day for Heal's, *Perpendicular* is a simple vertical colour stripe animated by the ebb and flow of linear marks.

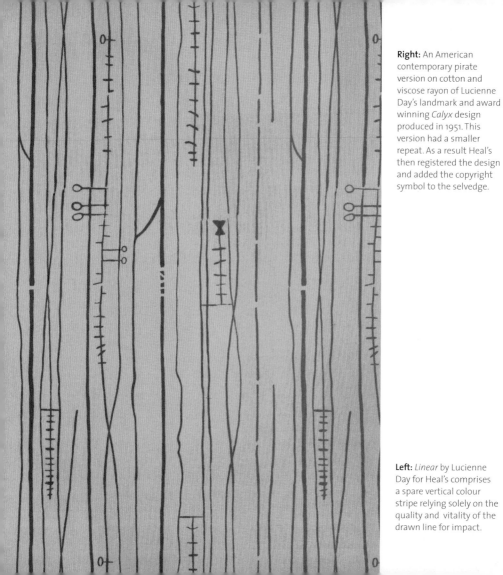

Right: An American contemporary pirate version on cotton and viscose rayon of Lucienne Day's landmark and award winning *Calyx* design produced in 1951. This version had a smaller repeat. As a result Heal's then registered the design and added the copyright symbol to the selvedge.

Left: *Linear* by Lucienne Day for Heal's comprises a spare vertical colour stripe relying solely on the quality and vitality of the drawn line for impact.

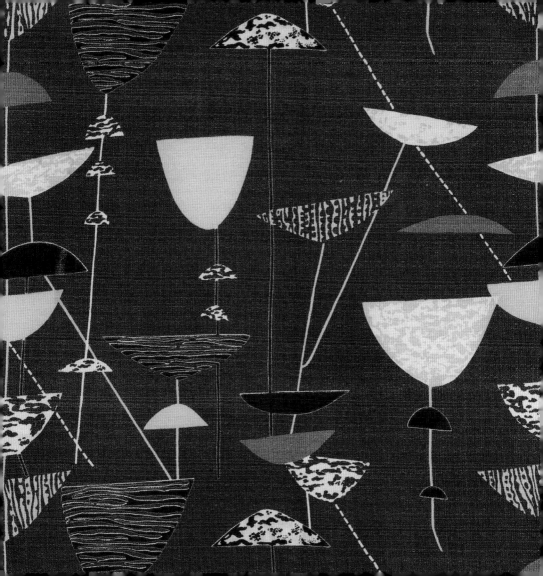

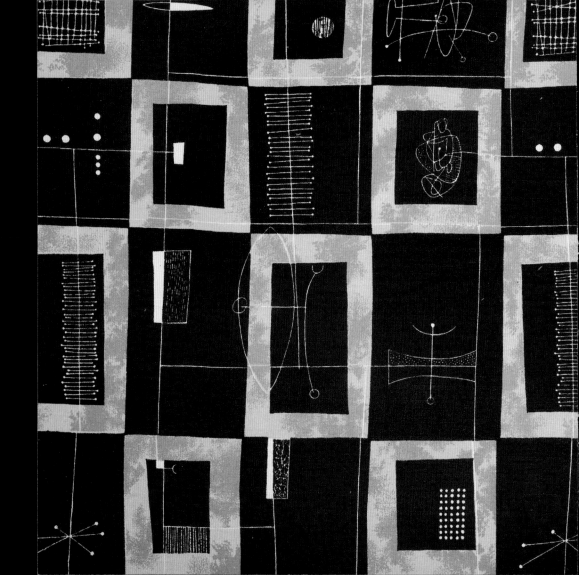

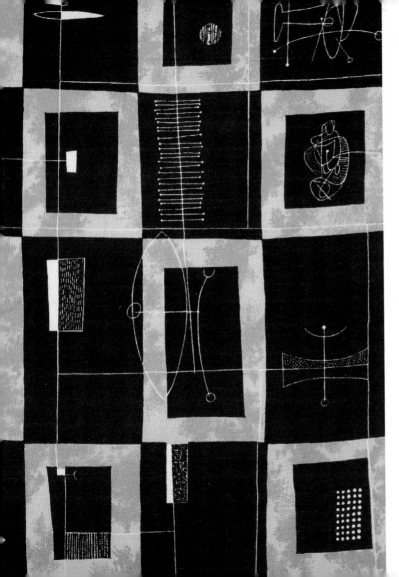

Left: An anonymous design that amounts to a primer of the necessary ingredients for lively kinetic 1950s textiles; free geometry, textures, mobiles and molecules.

Domestic

The consumer culture of 1950s Britain and America was fuelled by the return of women to the domestic arena, the rise of suburbia and a newly placed emphasis on the home. As Penny Sparke points out in As Long as it's Pink, 'The ... aesthetic feminisation of goods in this period, manifested in an explosion of pink radios, coloured appliances and a preponderance of pattern and texture in the domestic interior bore witness to the expanding power of the female consumer.' Pattern was the most important in these interiors: printed textiles and wallpapers were used to emphasize a single wall. These patterns were frequently based on the grid system of modular furniture. The grid was used in pattern design to isolate and enhance a motif, very often one that replicated a domestic artefact.

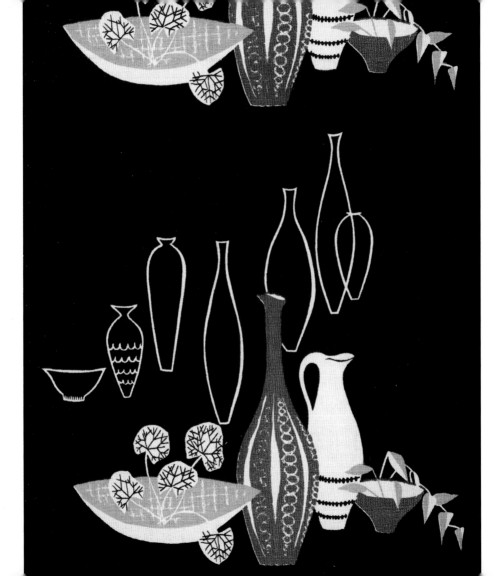

154

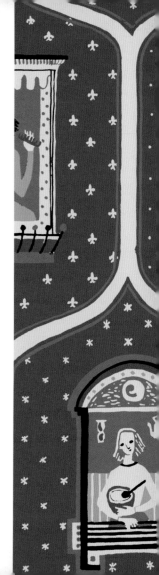

Previous page: A popular trend in the early 1950s was the use of domestic objects as design icons. The vases referenced in this design by David Whitehead are taken from examples of contemporary ceramics.

Right: The classic ogee-shaped repeat system is structured into a large scale repeat measuring 53.19cm (21in) in width and 41.66 cm (16½ in) in height. *Eglington* by Sylvia Chalmers describes a series of windows featuring people undertaking various activities in architecturally diverse windows.

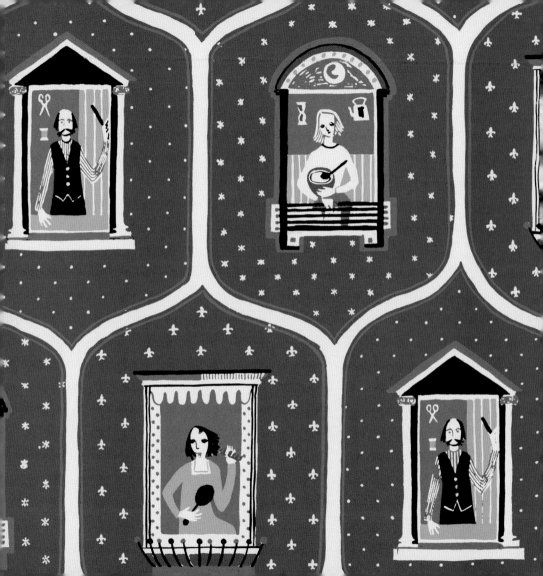

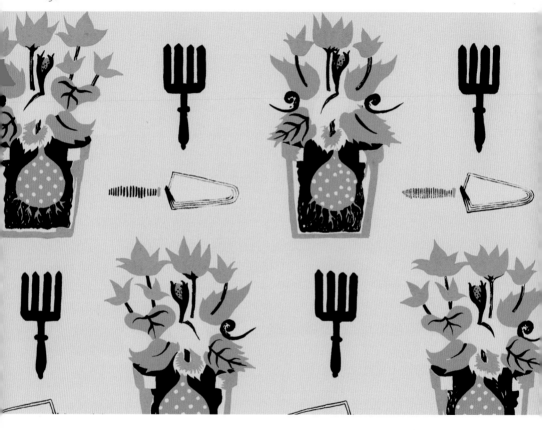

Above: A fresh and simple design by Sylvia Chalmers, *Flowerpot* features graphically stylized containers interspersed with garden implements. The repeat measures 51.41 cm (20 in) in width and 38.55 cm (15 in) in height.

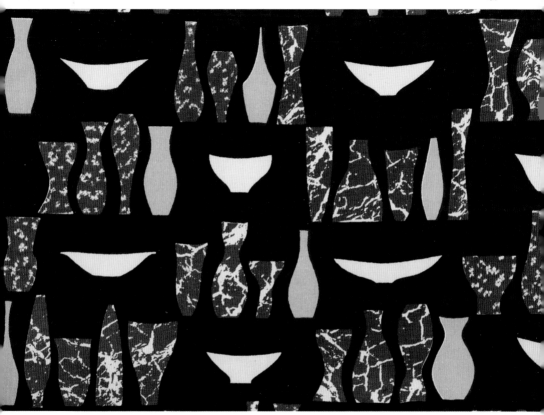

Above: The reverse-out silhouettes of ceramics and glass containers are another example of the elevating of mundane objects as design motifs in this unbranded design.

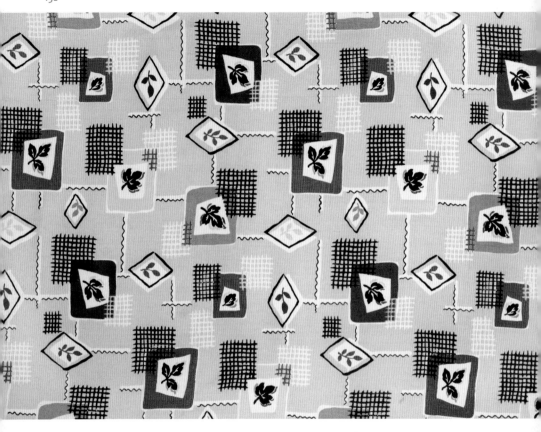

Above: This unbranded design with a small-scale repeat and undemanding content was probably destined for the mass market.

Right: An early design by Marian Mahler for David Whitehead dating from 1947. Roller printed on cotton and rayon, the design is small in scale and so particularly appropriate for domestic use.

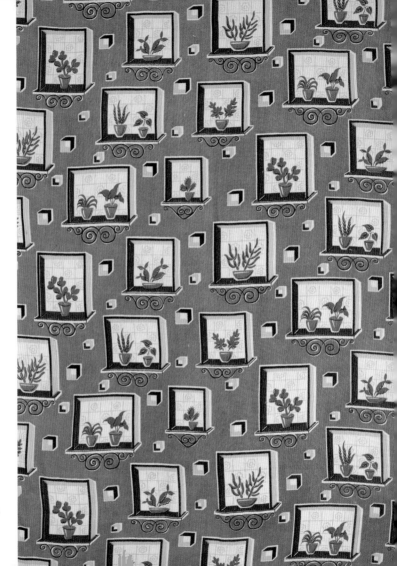

Right: Window-framed planters in half-drop repeat. The black wrought-iron shelf support is typical of 1950s domestic taste.

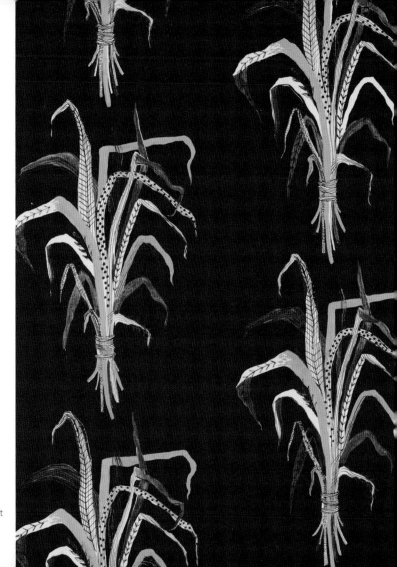

Right: Graphically explicit *Grasses* in a half-drop repeat and one-directional design measuring 44.90 cm (17½ in) in width and 61.96 cm (24½ in) in height by Sylvia Chalmers.

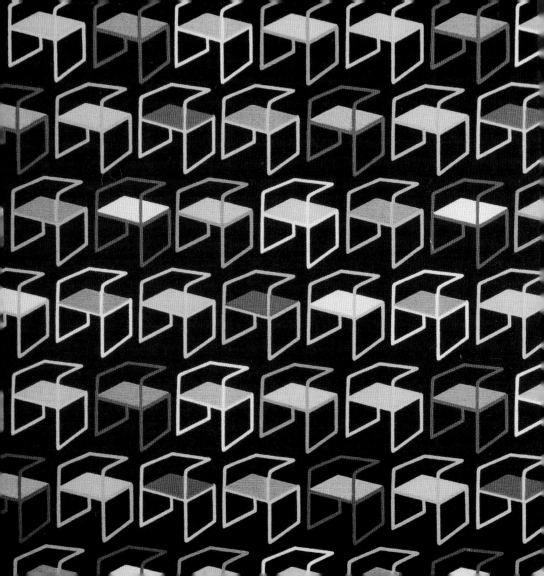

Left: This rigid horizontal offset repeat is kept lively by the ingenious colour distribution. Designed by Terence Conran.

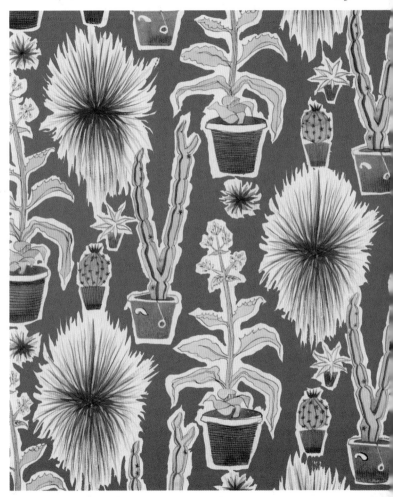

Right: Cacti were a popular choice in the 1950s household. *Califonia* by Sylvia Chalmers has a repeat width of 46.02 cm (18 in) and a height of 60.44 cm (23¾ in).

Above: Polychromatic stripes create a dynamic surface structure in this fashion fabric from the archives of British Celanese.

Above: A Technicolor deck-chair stripe for a dress that imbues the wearer with the exuberance of resort wear.

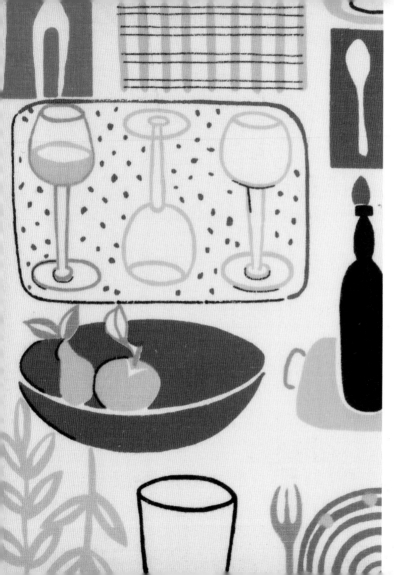

Right: Asymmetrical textured Swedish-style vases are overprinted with abstracted geometric leaves in this anonymous home-furnishing fabric.

Left: A classic 1950s Kitchenalia design with the bright palette and olive oil bottle suggestive of Provençal summers. Elizabeth David's 1950 book *Mediterranean Food* radically changed the approach to British cooking.

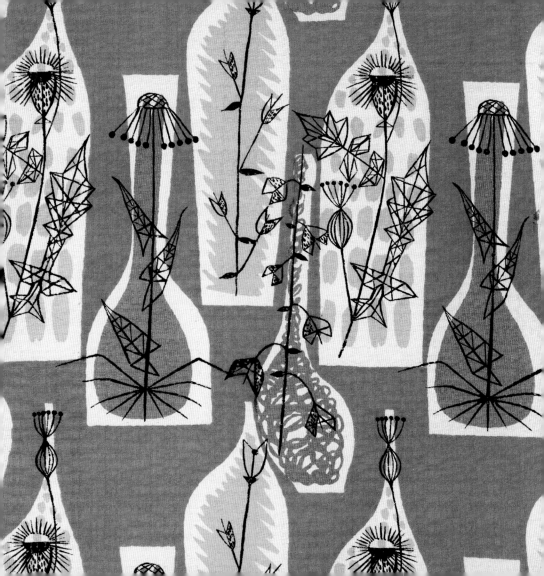

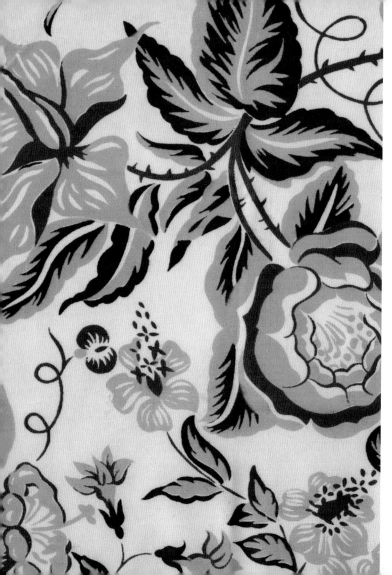

Right: A British Celanese print reflecting a freer and more spontaneous approach to pattern design.

Left: An all-over floral print design on rayon for domestic use from the archives of British Celanese.

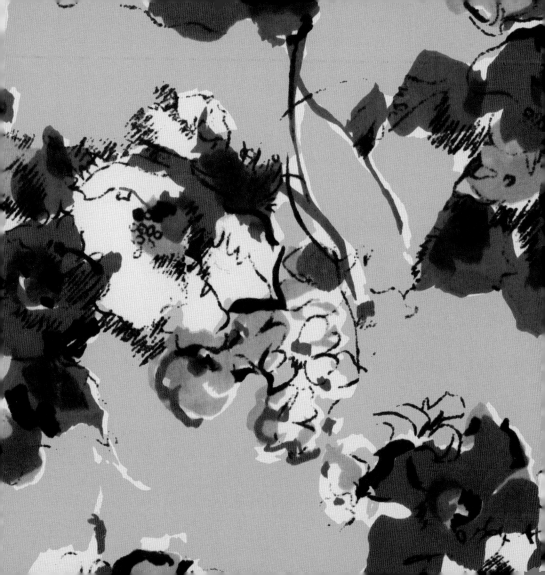

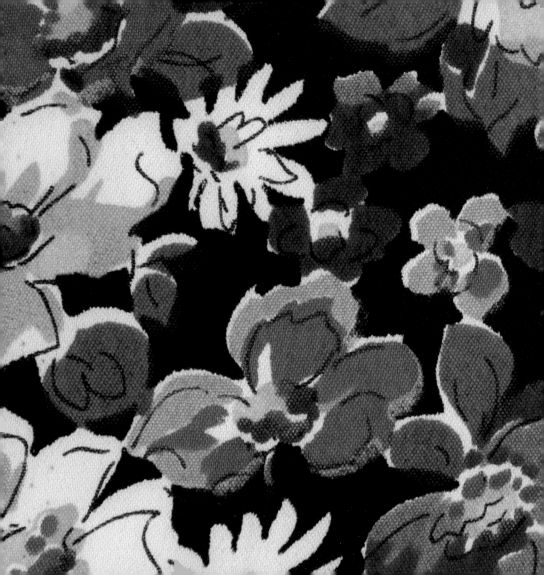

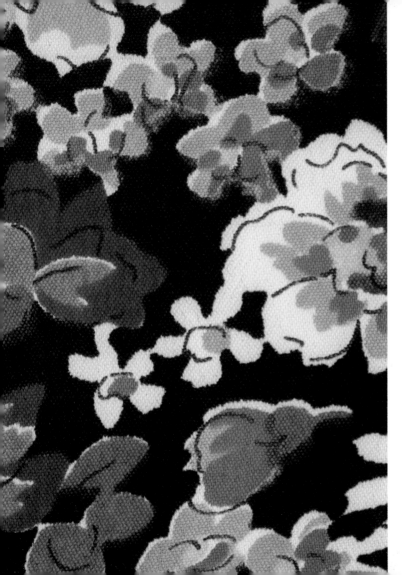

Left: A five-colour roller print by British Celanese moves out of the austere into heightened colour in this all-over floral design.

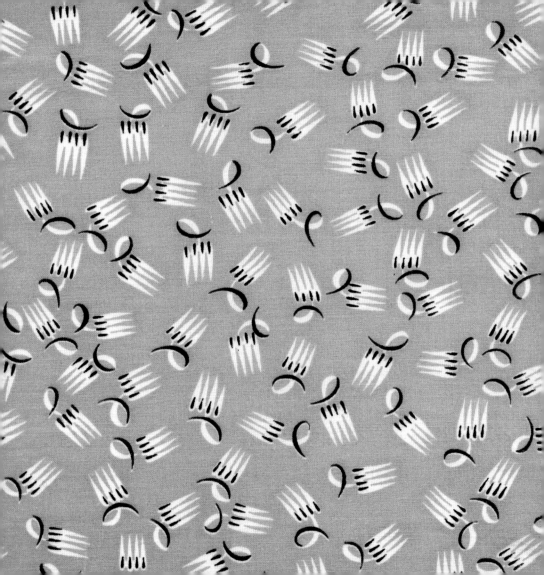

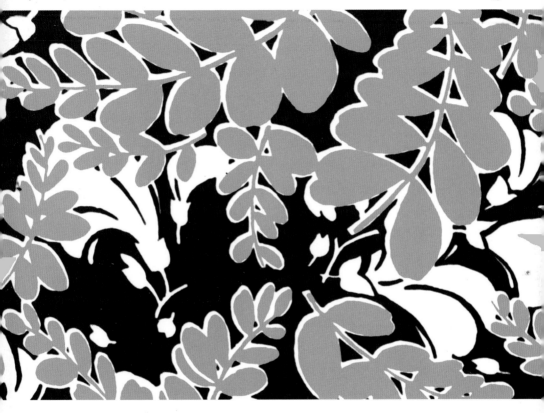

Left: Mass-produced fashion fabrics were slower to show the influence of contemporary design, as in this utilitarian two-colour print which would have been produced in various colours, the black remaining constant.

Above: Stylized acacia blue foliage is layered over off-set white space, with simple flower shapes, giving depth to the background.

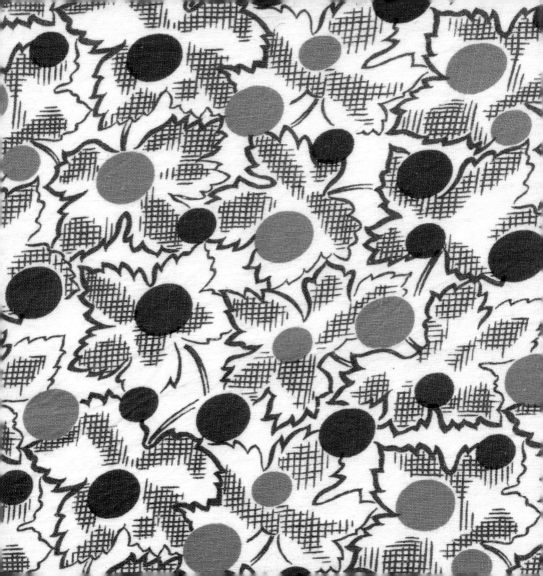

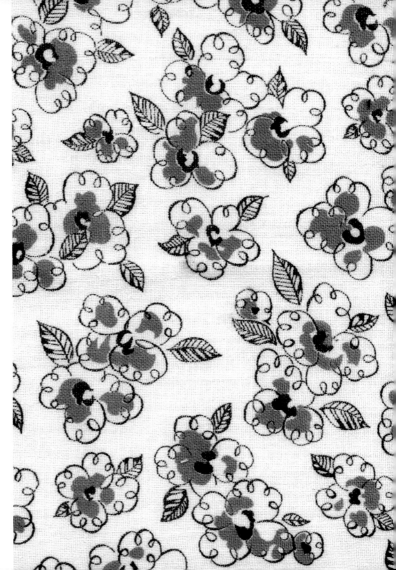

Right: A crisp utilitarian two-colour print offering maximum effect by the use of the white background.

Left: Stylized natural form interspersed with flat colour spots in this three-colour design from British Celanese.

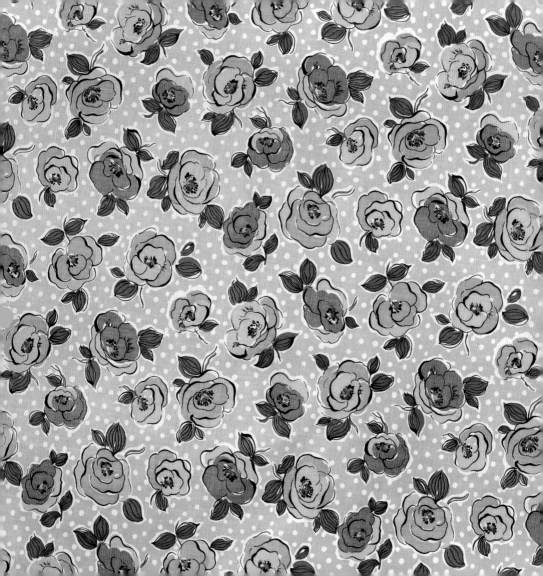

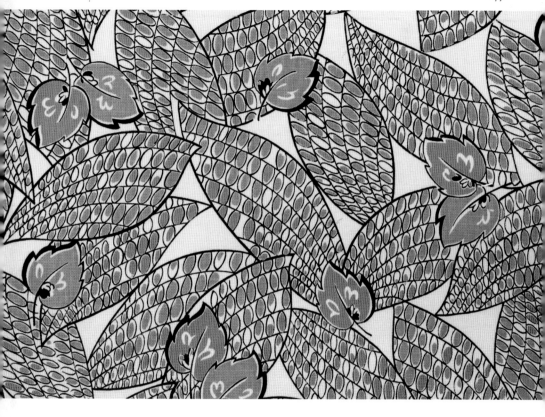

Left: The multi-directional floral motif of this fashion fabric is animated by the polka-dot background.

Above: The 3D effect of the small leaves printed on lightweight cotton would give an appliqué quality to the made-up garment.

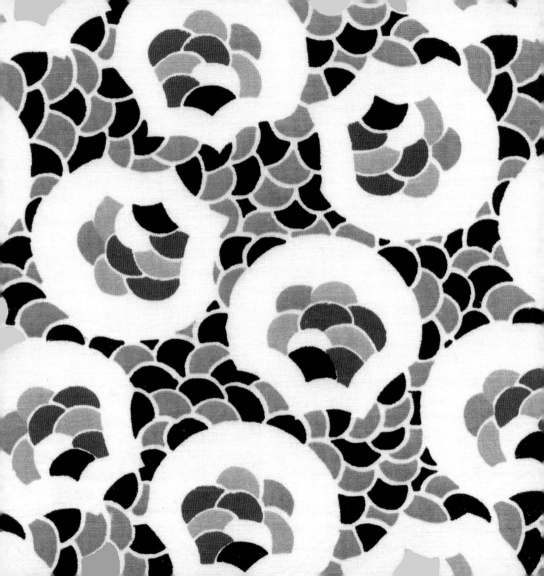

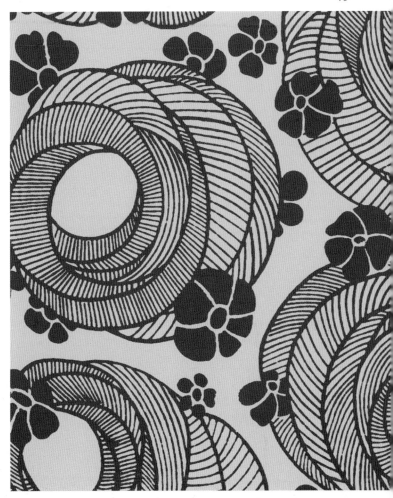

Right: A single-colour print on a pale background scatters small floral motifs behind and in front of hatched spiral forms, which recede into illusory space in a half-drop repeat.

Left: A non-directional print using the theme of scallop shells.

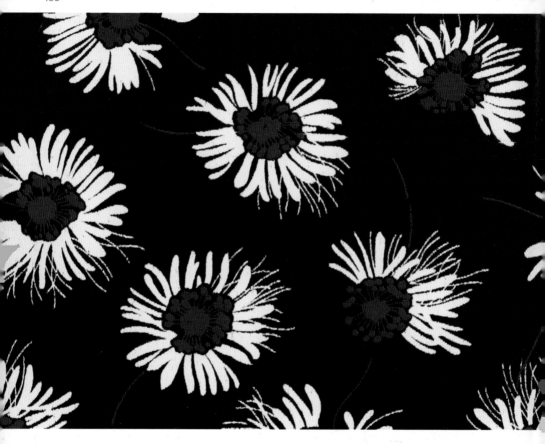

Above: Non-directional discharge print of daisy-like flowers scattered over a dark background and rendered with brisk painterly strokes.

Right: A simplified open floral design in several colours, illuminating the dark background (discharged to accommodate the highlight shades). The stylization shows the influence of Hans Arp's paintings.

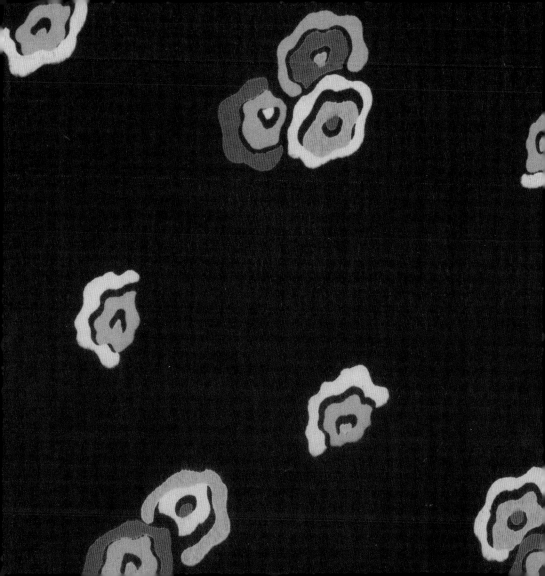

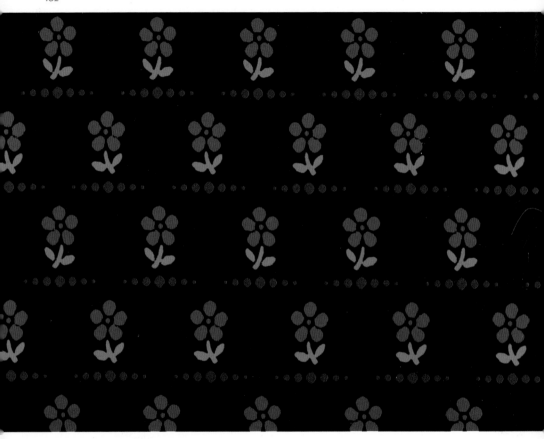

Above: This metronomic half-drop repeat of a small floral sprig has a simple drama arising from the dark background and primary coloured motifs.

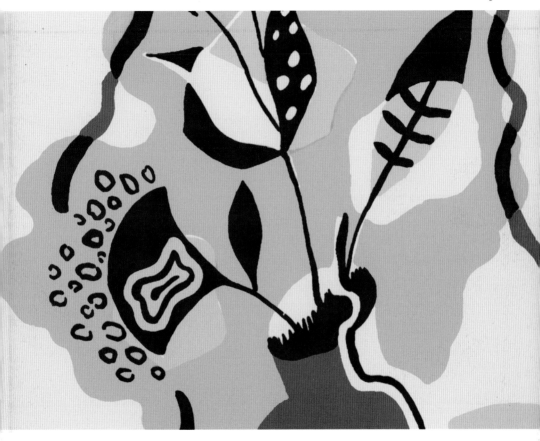

Above: From the archives of British Celanese, this one-directional vertical print design on rayon for the home furnishing market features independent abstract motifs.

Bibliography

Arthur, Liz. *Robert Stewart Design 1946-95*. The Glasgow School of Art Press in association with Rutgers University Press, New Brunswick, New Jersey, 2004

Buruma, Anna. *Liberty and Co. in the Fifties and Sixties.* Antique Collectors' Club Ltd, Suffolk, 2009

Galloway, Francesca. *Twentieth Century Textiles.* Antique Collectors' Club Ltd, Suffolk. 2007

Hine, Thomas. *Populuxe.* Bloomsbury Publishing Ltd, London, 1988

Jackson, Lesley. *20th Century Pattern Design: Textile & Wallpaper Pioneers.* Mitchell Beazley, London, 2002

Jackson, Lesley. *Robin & Lucienne Day: Pioneers of Contemporary Design.* Mitchel Beazley, London, 2001

Jackson, Lesley. *The New Look: Design in the Fifties. London*, Thames & Hudson, 1991

Peat, Alan. *David Whitehead Ltd: Artist Designed Textiles 1952-1969.* Oldham Leisure Services, Oldham, 1993

Rennie, Paul. *Festival of Britain 1951: Design.* Antique Collectors' Club Ltd, London 2007

Sparke, Penny. *As Long as it's Pink.* HarperCollins Publishers, London, 1995

Footnotes

1. Peat, Alan (1994). *David Whitehead Ltd: Artist Designed Textiles 1952–1969.* Oldham Museum Gallery, p8.

2. Peat, Alan (1994). *David Whitehead Ltd.:Artist Designed Textiles 1952–1969.* Oldham Museum Gallery, p16, quoting from *Design,* March 1958.